Images of America
Early Coal Mining in the Anthracite Region

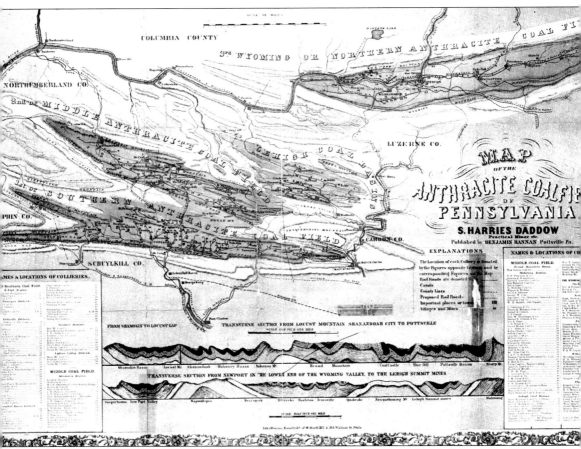

This 19th-century map, by S. Harries Daddow, features the northern, Lehigh, middle, and southern coal fields of the Pennsylvania anthracite region. It also shows the locations of all the operating collieries within the coal fields and their routes to market.

IMAGES of America
EARLY COAL MINING IN THE ANTHRACITE REGION

John Stuart Richards

ARCADIA
PUBLISHING

Copyright © 2002 by John Stuart Richards
ISBN 978-0-7385-0978-5

Published by Arcadia Publishing
Charleston SC, Chicago IL, Portsmouth NH, San Francisco CA

Printed in the United States of America

Library of Congress Catalog Card Number: 2001096516

For all general information contact Arcadia Publishing at:
Telephone 843-853-2070
Fax 843-853-0044
E-mail sales@arcadiapublishing.com
For customer service and orders:
Toll-Free 1-888-313-2665

Visit us on the Internet at www.arcadiapublishing.com

CONTENTS

Introduction 7

1. The Miner 9

2. Mining Operations 27

3. Mules, Drivers, and Spraggers 61

4. The Breaker Boys and the Breakers 85

Glossary 96

INTRODUCTION

This book takes the reader back in time to the early days of anthracite coal mining and to the heyday of Pennsylvania mining, between 1880 and 1930. From Wilkes Barre in the northern coal fields of Pennsylvania to the southern fields near Pottsville, the reader gets a historical view of 19th- and early-20th-century coal mining. The images depict the men and young boys who worked deep inside the anthracite mines of Pennsylvania. They show the blackened faces, the fire lamps burning on the miners' caps, the young boys working in unbearable conditions, and the different types of equipment used in the mines. The mining conditions are keenly depicted, and the aura that surrounded the men and boys is brought to life by these vivid images of the collieries of northeastern Pennsylvania.

Anthracite coal was first mined in the northeastern section of Pennsylvania in 1775 on an outcrop of surface coal in the Wilkes Barre area near the Susquehanna River. By the 1790s, coal was discovered in the Schuylkill and Lehigh regions of Pennsylvania. The first anthracite coal company, the Lehigh Coal Mining Company, was formed c. 1820. This company would begin the first processing and shipment of anthracite coal to market.

In the 1840s, anthracite coal mining became a full-time occupation for thousands of men throughout the anthracite region. The first miners came from England, Wales, and Scotland, bringing with them the knowledge and skills acquired from many years of mining experience. By the 1860s, Pennsylvania anthracite coal mining was a major industry, supplying all of the mined coal for the heating and industrial uses throughout the United States. By 1914, the anthracite region of Pennsylvania employed more than 180,000 workers. Coal production by 1917 exceeded 100 million tons per year (declining to 4.8 million tons per year in the 1990s). Along with this large industry came the fact that safety was needed within the mines. Between 1847 and 1980, more than 121,200 people died in coal mining accidents in the United States. By 1870, close to 15 men were killed in the anthracite mines per million tons of coal mined, bringing forth tough mine safety laws. Even with the advent of mine safety laws, more than 32,000 people have lost their lives in the anthracite coal fields of Pennsylvania since 1870. By 1900, a large majority of ethnic groups—Irish, Slavic, Hungarian, Polish, Lithuanian, and Italian—had settled in the anthracite region to work in the mines.

The images in this volume depict the daily lives of the miners. They reflect how the career of a miner progressed from being a young breaker boy to driving mules in the mines. Many of the images will bring back memories to the thousands of families whose grandfathers, fathers, uncles, and brothers worked in the anthracite coal mines of northeastern Pennsylvania. The

photographs also show the process of mining coal, the digging of shafts, the driving of gangways, the working of the breasts, the blasting of the coal seam, and the hoisting and haulage methods. Shown, too, are the wonderful mules who shared the dangers and hardships with the men and boys of the mines. Also, the breakers that once dotted the landscape of northeastern Pennsylvania by the thousands are shown in unique views. The children who worked in the cruel and harsh conditions of these industrial monsters, the coal breakers, are vividly depicted. These images are just small sample portraying what the vast industry of anthracite coal mining was all about. It is the hope of the author that these long-gone historical views will be enjoyed by one and all.

—John Stuart Richards

One

THE MINER

"Forty years I worked with pick and drill, down in the mines against my will: The coal king's slave but now it's passed, thanks be to God I am free at last." This short epitaph—that of Condy Brislin, a coal miner from the anthracite fields of Pennsylvania—sums up the story of the thousands of men who worked and died in the coal fields. For six days a week, from sunup to sundown, the miner labored in his underground workplace. He worked in a place where danger was his constant companion. He never knew whether he would be killed by a fall of coal and rock or burned alive by the explosion of methane gas. Nevertheless, men from England, Wales, Ireland, Scotland, Germany, Italy, Poland, and Slovenia worked and died in the anthracite coal fields of Pennsylvania.

The miner started his career as a breaker boy, picking slate in the breaker at age 10 or 12, and then went underground as a driver boy. As he got older, he worked his way up to a laborer and then got his papers as a miner. After many years, working in the smoke- and dust-filled chambers of the mine, he would develop miner's asthma, better known as black lung. The miners had an old saying: "Once a man, twice a boy." The phrase describes how a miner would start as a breaker boy and finally, after many years, when he was no longer able to perform as a miner, how he would return to the breaker as an old man.

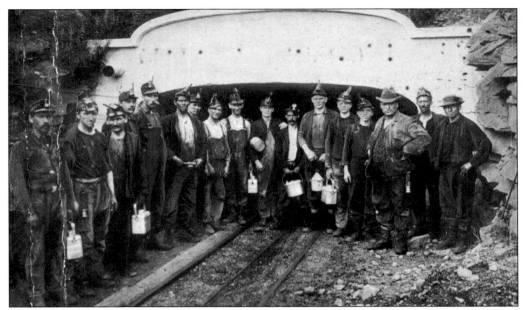

The shift is over. In this c. 1914 view, miners stand near the entrance of the tunnel, holding their dinner pails and canteens. Some are holding their Davy safety lamps. In the early days, a miner's shift could sometimes last 8 to 12 hours. In 1898, miners went on strike to institute an eight-hour workday.

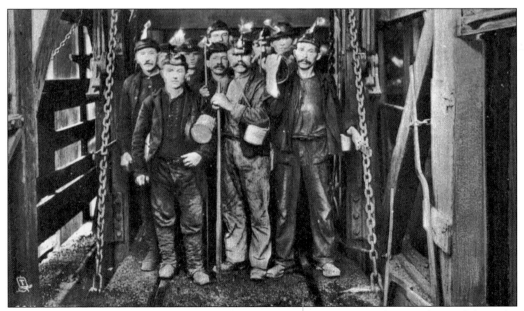

In this 1880s photograph, the miners are exiting the shaft on a cage that was hoisted from the mine. One miner holds a bar-down tool, used for prying down loose rock and coal. Another carries a tamping rod, and the miner on the right holds a round can of blasting powder.

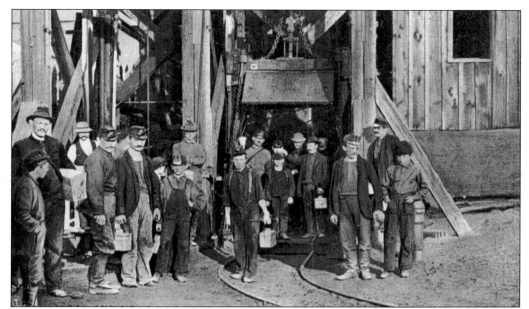

Miners, nippers, and driver boys are shown about to enter the cage above the shaft entrance of a mine. In a shaft entrance, the cars, miners, and equipment were raised and lowered on cages. The heavy metal atop the cage is called the bonnet, used to protect the men from falling debris. The cage was built principally of wood.

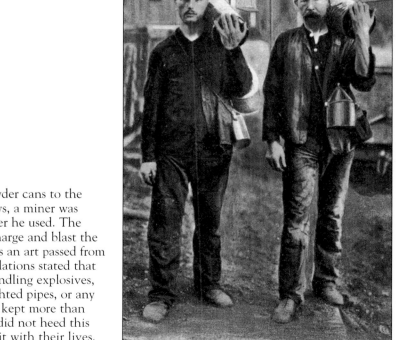

Two miners carry powder cans to the mine. In the early days, a miner was charged for the powder he used. The proper way to set a charge and blast the coal from the face was an art passed from miner to miner. Regulations stated that while miners were handling explosives, open-flame lamps, lighted pipes, or any source of fire must be kept more than five feet away. Many did not heed this warning and paid for it with their lives.

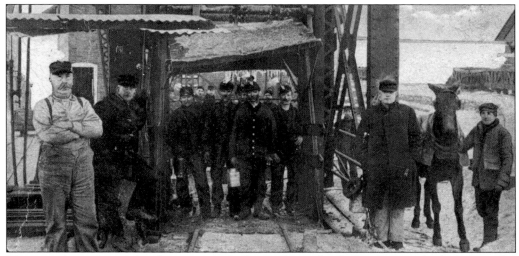

Miners and a mule with his driver wait to be lowered into the shaft. The size of a shaft depended on the use for which it was intended and was usually determined by the hoisting, drainage, and ventilation conditions used at the mine.

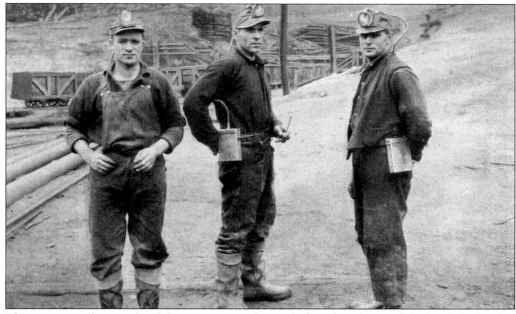

This is an excellent study of three miners in the era before the advent of the hard-shell safety helmet. Note that they still wear a soft miner's cap, but with the new electric lamp and battery pack attached to their belts. The advent of the battery-powered lamp saved many a miner from the danger of exploding a pocket of fire damp with an open flame.

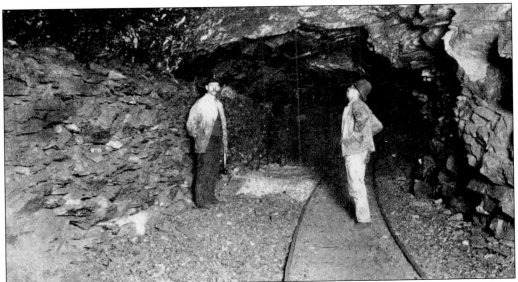

The inside boss and another miner inspect a crack in the roof of the gangway. The inside boss, or mine foreman, was in charge of all operations inside the working mine. He was responsible for all matters concerning ventilation, removal of coal, airways, timbering, and drainage. He would not allow any person to work in an unsafe area. As in this case, the area would be blocked off and danger signs would be posted nearby.

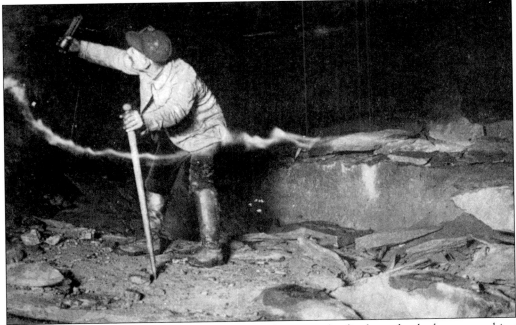

Every morning, two hours before the men entered a mine, the fire boss checked every working place for gas. Before allowing the miners in, he checked that the proper ventilation apparatus was working and that air was circulating the proper course. He used only an approved safety lamp. After completing his examination, he would mark his initials and date on a timber or piece of slate.

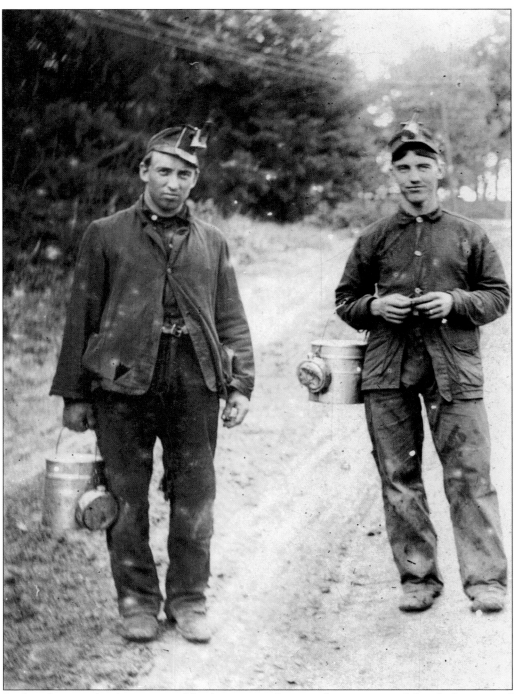

In this photograph of a miner and his butty, note the ragged appearance of the clothes, typical dress of the 1890s miner. They carry their ever familiar dinner pail. An old mining refrain laments, "Preserve that old kettle so black, neat and worn. / It belonged to my father before I was born. / It hung on the corner beyond on a nail. / It's the emblem of labor my dad's dinner pail."

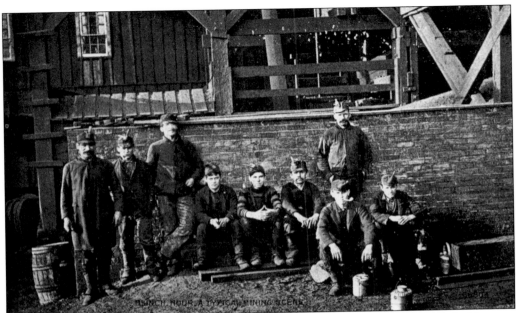

Many ethnic groups shared the dangers of coal mining, including the Welsh, English, German, Irish, Polish, Italian, and Slavic. While looking at these men and boys, one may wonder from what nation they hailed. John Mitchell, president of the United Mine Workers Association, once said, "The coal you dig is not Slavish coal, or Polish coal, or Irish coal. It's coal."

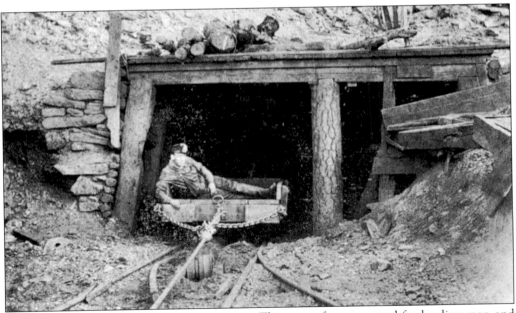

A miner is being let down into a slope mine. This type of car was used for hauling men and equipment. It was attached to a heavy wire wound rope that was connected to a drum in the engine house, where the hoisting engineer let out the prescribed length of rope to reach the different levels of the mine.

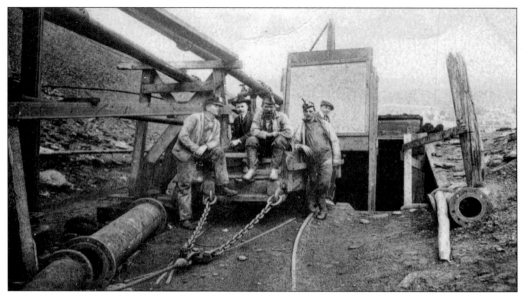

In this c. 1910 photograph, three miners and two visitors sit on a slope car, ready for the descent into the slope. This was a typical car used in slope mines. The spreader chain was attached to the two couplings on either side of the car. Note the large-gauge pipe lying about. This pipe was used for pumping water to the surface.

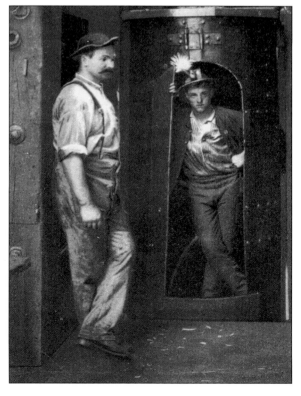

This old-style entry into a shaft was prevalent in the English and Welsh coal mines of Europe.

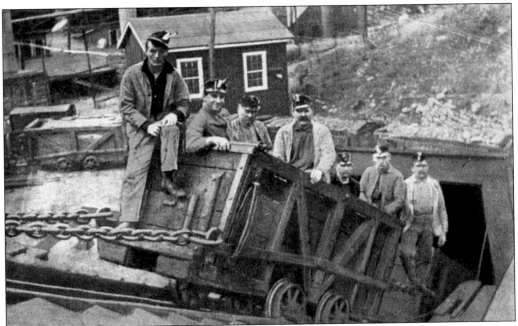

Seven miners are being lowered into a slope on a car designed for use in a slope entrance. Observe the heavy spreader chain attached to the couplings on either side of the car. Cars like this could not be used on the surface for pulling a trip of cars.

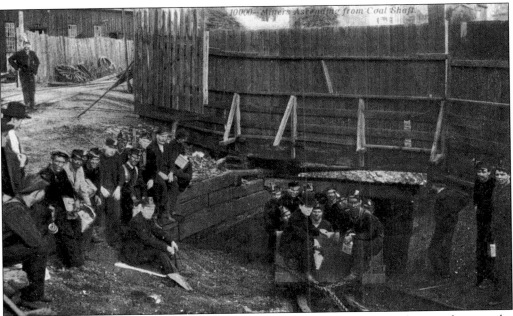

In this c. 1900 photograph, miners ascend out of a slope. Note the man riding on the spreader chain, a very dangerous and unsafe method of riding a car. Many miners and boys were injured or killed through their own carelessness while working around moving cars.

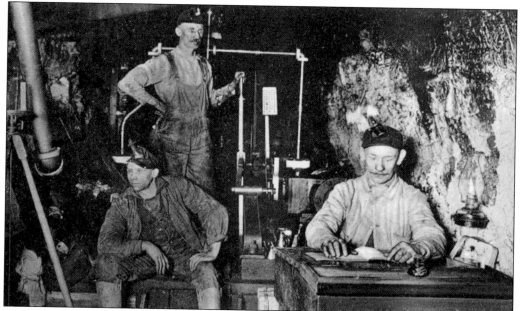

An inside boss is doing his paperwork c. 1890. In some mines, the area for the inside boss was enclosed. Also included in the boss' area would be the peg board. At every mine where more than 200 people were employed, a check system was adopted. Each person entering the mine showed a brass check with a number on it to the boss. It was then placed on the board and, when the person left, was removed.

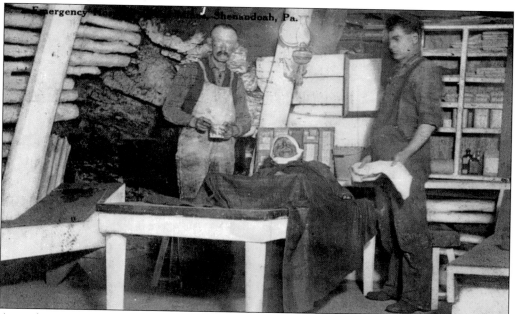

According to mine safety laws, every mine was to be provided with a room inside to be known as the emergency hospital, so that medical treatment could be promptly given to an injured employee. The hospitals were erected at a convenient place inside the mine. This is an early mine hospital c. 1888. Note the whitewashed timbers and the old oil lamp.

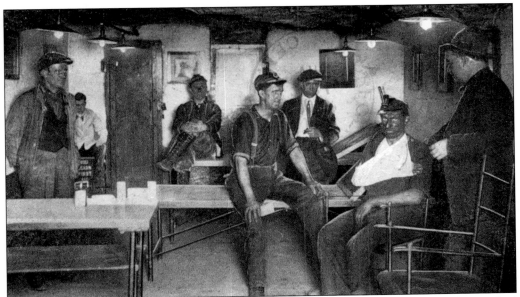

This view shows a hospital inside the mine c. 1920. The hospital is enclosed in a whitewashed room with electric lighting. Mine law also stated that the hospital must be well ventilated and must be supplied with linseed oil, gauze bandages, splints, and woolen blankets.

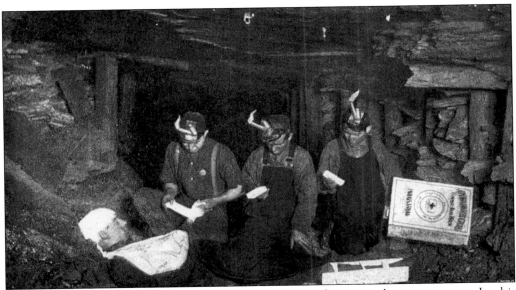

Each colliery was required by law to provide one first-aid corps and a rescue corps. In this photograph, the first-aid corps is tending to an injured miner, using an industrial first-aid kit. By law, the inside boss had to arrive on the scene and make sure the proper care was administered to the injured.

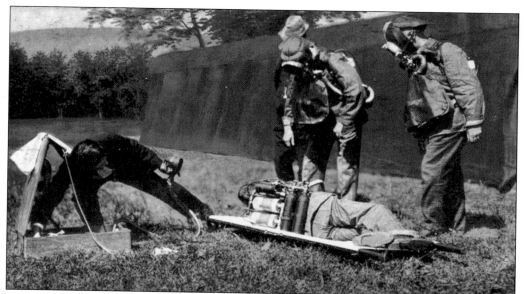

A mine rescue crew is shown using oxygen helmets. The law required a colliery employing more than 200 people to have a rescue crew with a sufficient number of modern rescue helmets, as well as a sufficient quantity of oxygen to last for 48 hours.

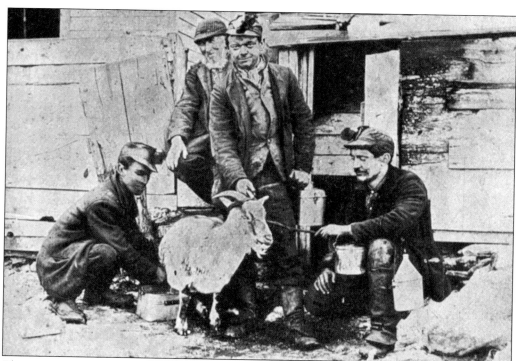

This is an excellent photograph of three miners on their way to work. The miners have probably paid the older man a few cents for some fresh goat's milk. The young man is milking the goat right into his growler.

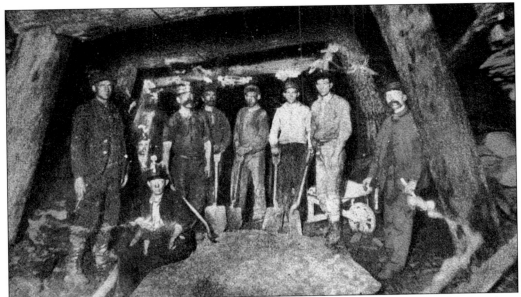

A labor crew is shown inside the mine. Note the small, wood-handled shovels used for mucking dirt. Not everyone who worked in the mine was a miner. Many men were just known as the inside crew men who built the stables, drove gangways, shoveled, and hauled away the rock and dirt.

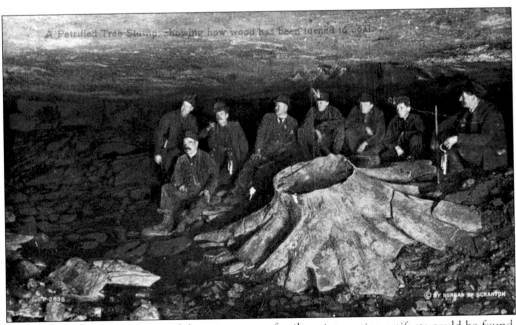

Inside the deep, dark recesses of the mine, many fossils or interesting artifacts could be found. Here, some miners find a petrified tree, thousands of years old.

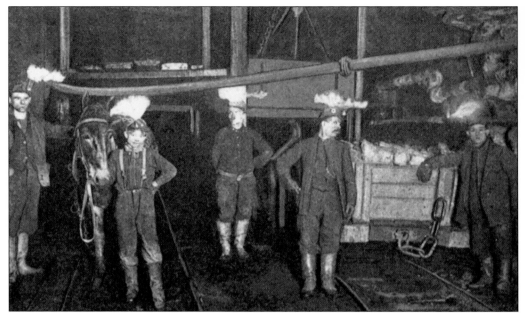

A loaded car is being readied for hoisting to the surface through the shaft. The car, after being unhooked from the mule, would be pushed into the open cage, and the signal for hoisting would be sent to the engine house. The signals consisted of one rap or whistle, which meant hoist the coal or stop the gunboat when in motion. Two raps or whistles meant lower the car. Three raps or whistles meant hoist the men.

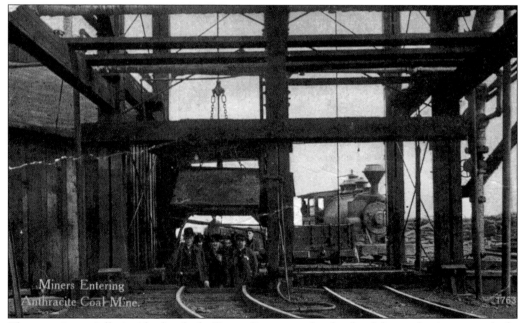

The cage is partially inside the shaft. Depending upon the depth of the coal vein, some shafts were sunk well over 1,000 feet into the earth. The shaft at the Otto colliery in Branchdale, Pennsylvania, went down to a depth of 1,207 feet.

Ready for the surface, a loaded car with the chalked-on number 135 is about to be hoisted to the surface. The number indicated the worker who mined the coal. The ticket boss at the breaker would determine the weight and quality of the coal, and the miner would be paid according to that information.

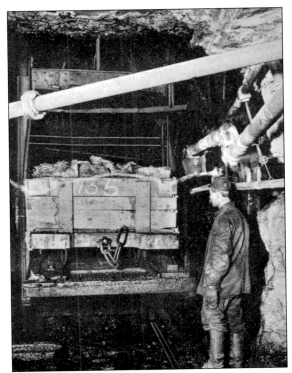

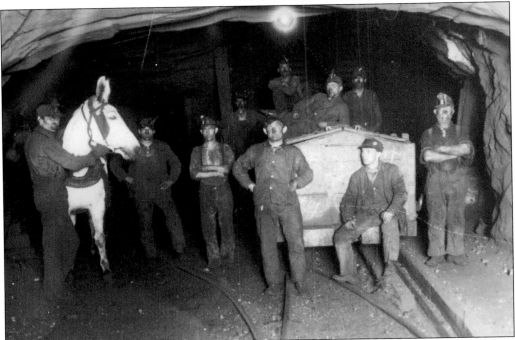

Miners and boys pose at the bottom of the short Mount Slope, near Lykens. In the front are, from left to right, Ted Grenner (holding the mule), Sam Kreiner, France Ely, Bob Matter, Howard Yench, and Cook Long. (Courtesy Marlin Umberger.)

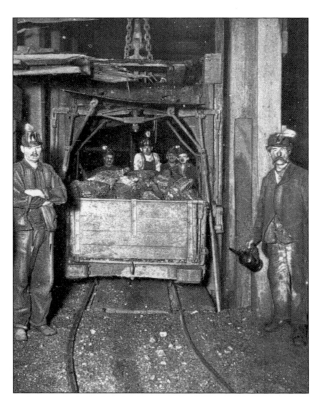

In this view of a loaded car sitting on the cage, note the miner holding the oil can, which was used for filling the oil wick lamps on the miners' caps. Mine rules prohibited people from riding to the surface on loaded cars.

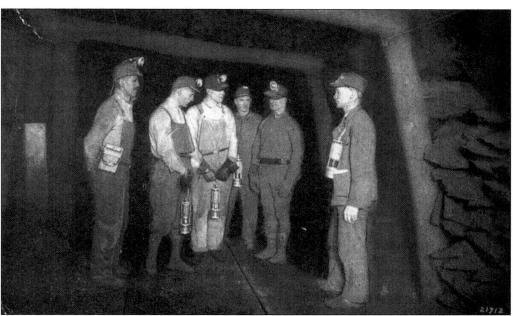

Miners stand in the gangway of a mine c. 1920. The men are wearing battery-powered electric lamps atop their hats. They also carry the Kohler safety lamps, used for detecting different types of gas in the mine.

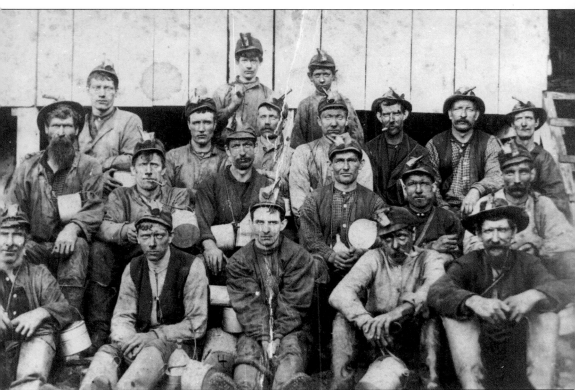

A picture tells a thousand stories—the true look of the early anthracite coal miner. Note the early-style lunch containers and canteens, the clay pipes, gumboots, and the various hats with attached oil wick lamps. "I work in the mines where the sun never shines / nor daylight does ever appear / with me lamp blazing red on top of me head / and in danger I never know fear." —From the ballad "The Hard Working Miner," by Patrick O'Neil. (Courtesy Schuylkill County Historical Society.)

Every miner had to be certified. In order to become a miner, a man had to have worked two years as a laborer in the state of Pennsylvania and must be able to answer 12 English-language questions pertaining to the requirements of a practical miner on safety and techniques. This miner's certificate is for George Richards, who started work as a breaker boy in 1897 at age 10 and progressed up to a miner. He died in the Gowan mine in Hazelton, Pennsylvania, at age 53.

Two

MINING OPERATIONS

The underground workings of the colliery was called the mine. The entrance to a mine was by a drift (a horizontal tunnel cut into the face of an outcrop of coal), a slope (which followed the different dips of the coal seam from the surface), or a shaft (which extended vertically from the surface to the different veins of coal). From the foot of the shaft or slope, a tunnel called the gangway was opened to either the right or left of the coal seam. Parallel to the gangway and slightly higher was another tunnel called the airway. They were all interconnected by way of small tunnels called cross headings. The main gangway was the highway inside the mine used to haul the mined coal from the different working chambers to the surface. Inside the mine, different methods were used for the process of bringing the coal to the surface. The mining of anthracite coal was usually done in the room-and-pillar method. In this method, chambers were opened into the vein of coal at right angles. The place where the coal was being removed was called the working face, or breast. There could be many breasts in a large mining operation. The section between the breast was called the pillar, which contained coal that was left in the vein to help support the roof. The miners used many tools in their trade: picks, shovels, tamping rods, bar-down tools, crosscut saws, timbering tools, hand-held auger drills, pneumatic power drills, and many different size drill bits.

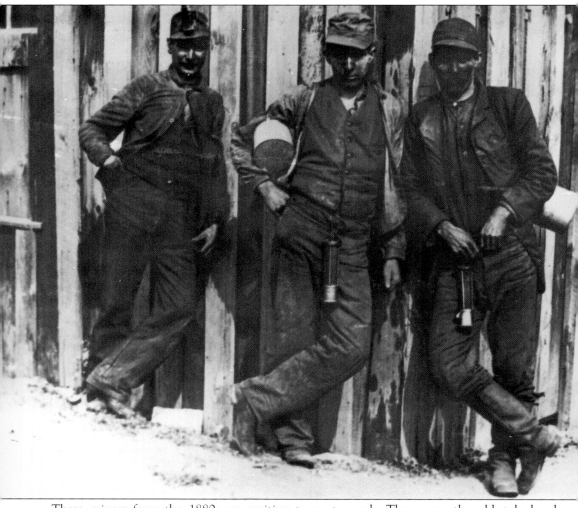

Three miners from the 1880s are waiting to go to work. They carry the old-style lunch containers. Hanging from their belts are the original safety lamps called Davy lamps, used for lighting and checking for gas. (Courtesy Schuylkill County Historical Society.)

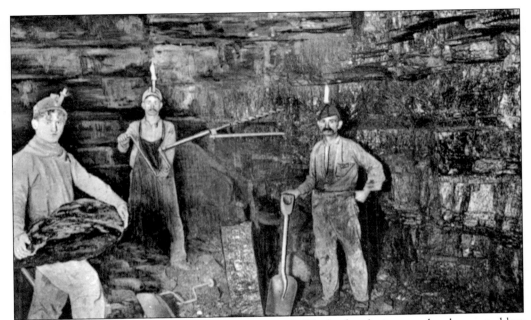

Working at the face, this miner uses a hand auger to drill holes for placing powder charges to blast out the coal. Holes were drilled at various angles in the face of the coal. The holes were then packed with a squib charge of black powder, covered with dirt, fused, and set off. After the coal fell, the miner's laborer, or butty, would shovel and hand-load the coal into the empty car.

These miners, working in the upper portion of a chamber, are wearing carbide lamps on their hats. Carbide lamps were the next progression of mine lighting after the open-flame oil wick lamp. The base of the lamp contained carbide pellets, and the top was filled with water, which slowly dripped on the carbide and created acetylene gas. This was ignited by a striker on the reflector plate, creating a bright-white open flame.

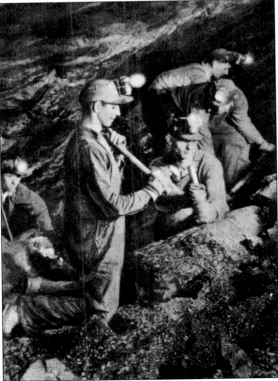

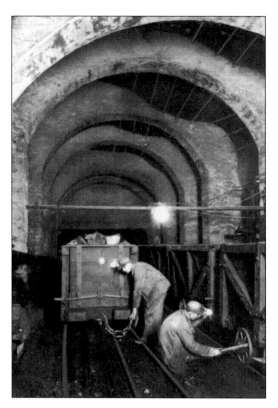

Pictured is a method of supporting a mine roof without the use of timbering. This mine uses concrete for the structure. The miner in the foreground is in the process of spragging a car. A sprag, a piece of wood about 14 inches long and pointed at both ends, would be inserted into the wheel of the car to keep it in place.

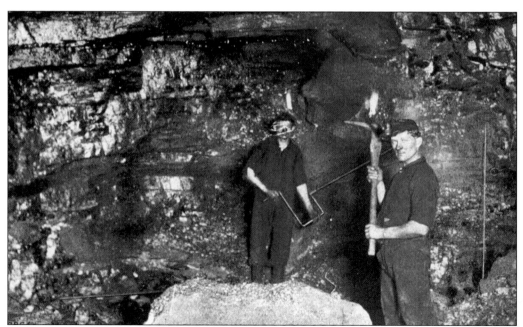

This is another example of a miner and his laborer working in a breast. The miner is drilling with the hand auger while the laborer uses his miner's pick to dig out coal.

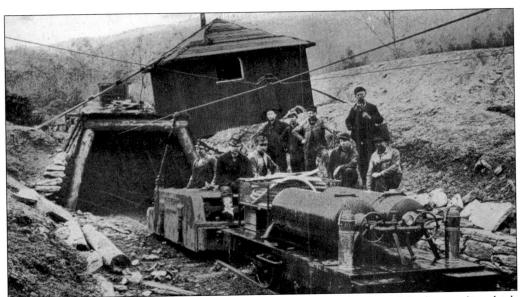

One of the most feared dangers in a mine is that of fire. After the Avondale disaster (in which 108 miners and boys were trapped underground and suffocated or burned to death), many new safety programs were incorporated at the collieries. This scene shows an electric mule pulling a car with associated firefighting apparatus that could be quickly pulled into a tunnel or used inside the gangway.

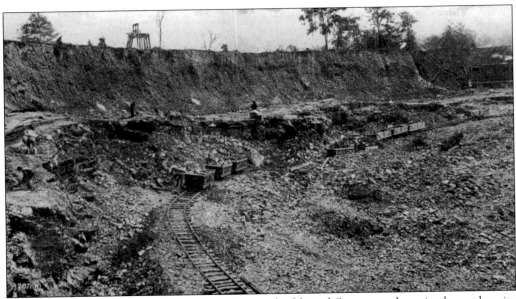

The most extensive coal-stripping operations in the United States are those in the anthracite region of eastern Pennsylvania. Coal sometimes outcrops near the surface, where the coal can be easily reached. Company policy was not to waste any marketable coal.

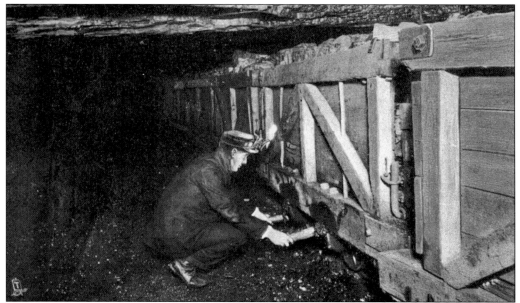

A mine haulage road sometimes had a very steep grade, requiring the cars to be held steady. Since they did not have fixed brakes, wooden sprags were used. The pointed sprags were placed in the open spokes of the wheel, where they would lock against the frame and act as a brake. Young boys would sometimes run alongside the car, putting the sprags in the wheels to help slow down a moving car.

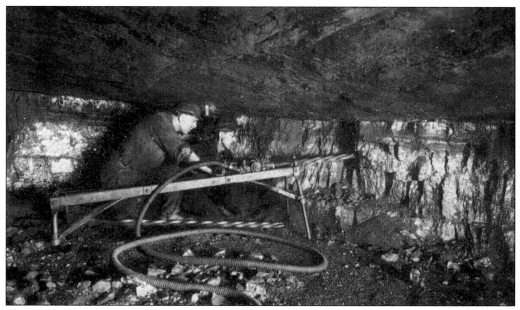

A miner and his assistant use a pneumatic drill to undercut the coal face. Note the height of the chamber in which these men are working. The drill is fixed upon a metal brace to help support the weight.

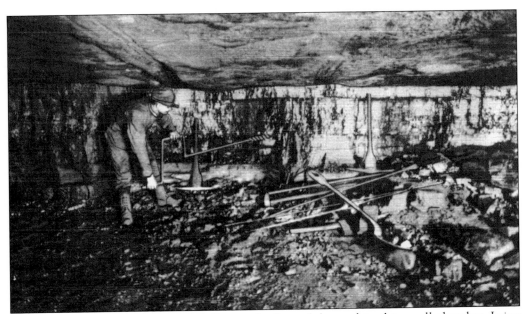

A miner is using a hand auger to drill into the face of the coal in this small chamber. Lying beside him are some of the tools of his trade—shovels, a tamping rod, picks, an axe, and a bar-down tool (used for pulling loose rock and coal down from the roof of the chamber or gangway). The tamping rod was used for tamping dirt into the hole. After this action, the blasting charge was set.

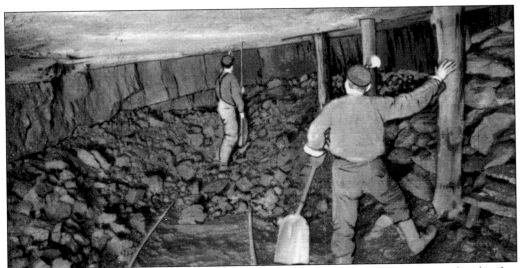

After blasting the coal from a vein, the miner is checking the integrity of the roof with a bar to see if additional timbering will be needed to support the roof. Note that the track has been laid right to the end of the working face.

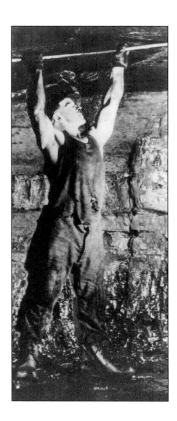

A miner works overhead to pry down the loose rock in his chamber. Any loose or unstable rock could fall and crush the miner, so it had to be removed. When a roof was unstable, it was considered "pressing."

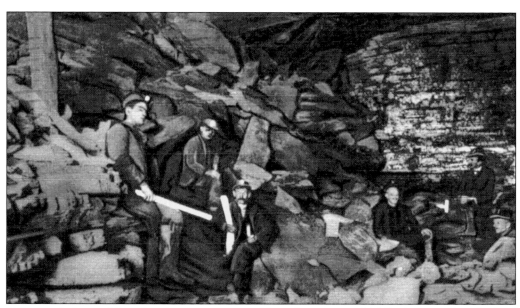

If the roof of a working chamber became unstable or loose, it could fall, dropping hundreds of tons of coal and rock. The miners tested the overhead rock by sounding it. By the ring of their tools hitting the roof, they could tell how stable it was.

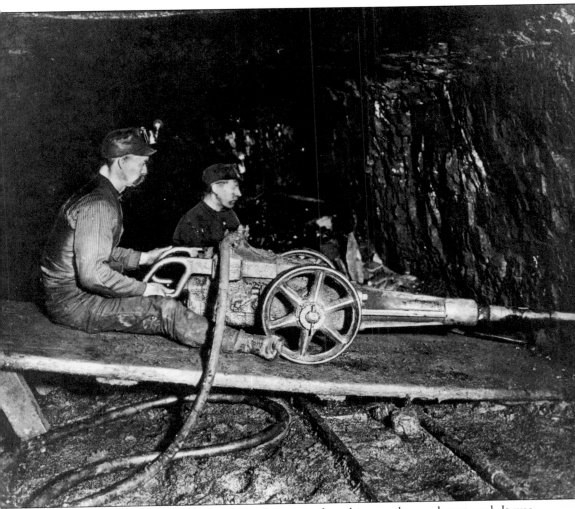

These miners are using a pick machine, the first type of machine used to undercut coal. It was placed on a platform that was inclined toward the face in order to neutralize the recoil, making it easier for the operator to advance the machine as it cut deeper into the coal. The pick struck between 190 to 210 blows per minute. The helper shoveled away the debris with a special handled shovel. (Courtesy Schuylkill County Historical Society.)

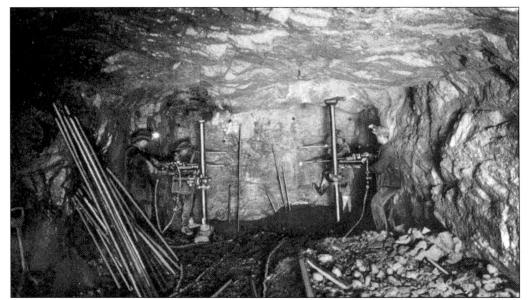

In this scene, men are driving a gangway through solid rock with a powered auger drill. Compressed air was supplied to the engine that drove the drill. Instead of a feed screw, there was a piston cyclic rod. The brace supported the extra weight of the drill. Note all the drill bits stacked against the wall.

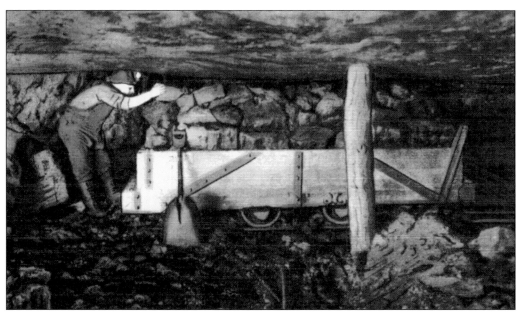

Working in close quarters, the laborer loads a low-sided car inside a small chamber. After the car was loaded, the laborer would whistle or yell for a driver to bring his mule and haul out the loaded car.

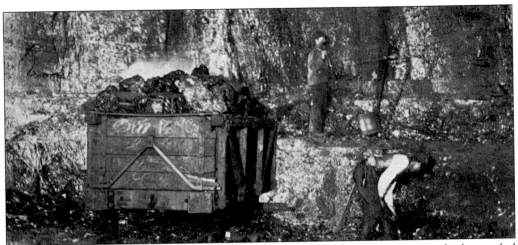

In this view, the miner and his laborer are using a method called bench mining, which entailed working on two or more thick seams of coal, usually composed of two or more benches and separated by clay, slate, or rock. The layers of coal were quite different in quality and value.

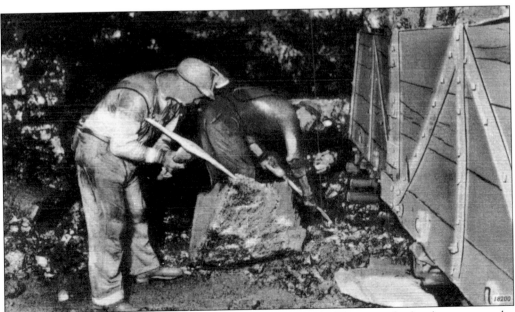

The miner is separating the coal from the slate with his pick. The miner had to learn to use the pick either right-handed or left-handed. Experience taught him how to cut different coals and how to hold the handle so that coal would not fly into his face.

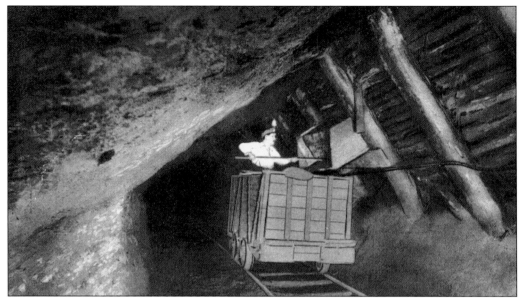

In sharply inclined veins of coal, the method of mining was called pitch vein mining. The gangway was driven on the strike of the seam with a narrow opening called a chute, opening off the gangway and widening out to the full width of the breast. A timbered chute conveyed the coal into the car on the gangway.

This miner is beginning the process of mining called undercutting. In order to take advantage of the roof pressure, the coal was undercut. This consisted of cutting away, with a pick or mining machine, the lower portion of the coal seam, as shown. When it was undercut by hand, the miner lay on his side. The fine coal was loaded into the car along with the lump coal.

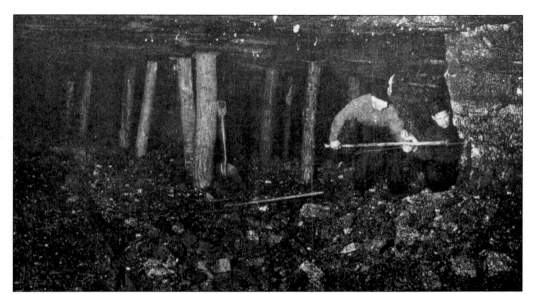

One of the most dangerous processes of coal mining is "robbing the pillars." After a mine is worked out, the only remaining coal left is in the pillars supporting the roof. Miners were often sent back in to remove the pillars. Starting at the far end, they would cut and bring out the coal in the pillars, sometimes allowing the roof to collapse behind them.

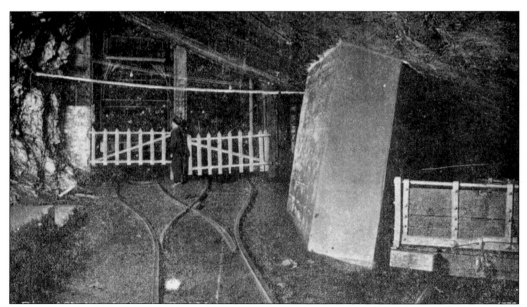

This is an interesting view of the foot of the shaft, showing an intricate double track and a large concrete pillar used to support the roof.

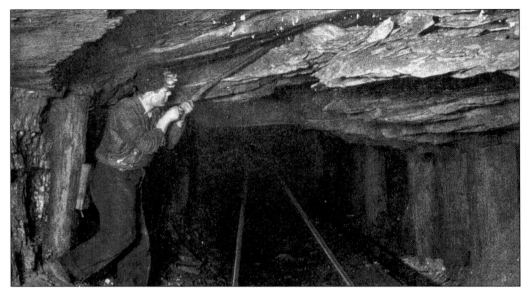

This miner is prying down the loose top rock and slate on the roof of the gangway, making sure the roof is safe. The most dangerous type of roof in a coal mine is one that does not break readily and contains slip.

There were many dangers in a coal mine. In this view, an electric mule has broken through a wooden door that the nipper, or door boy, on the other side failed to open in time.

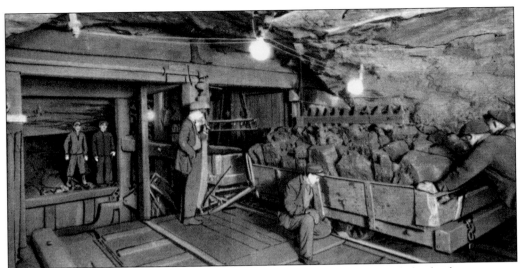

At the foot of the shaft, two men push a loaded car into the cage while the bottom man stands ready to give the signal to the hoisting engineer. Notice the supports and bracing of the cage area.

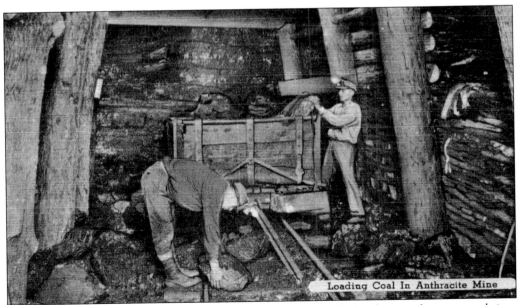

Two laborers load coal at the face. Using a piece of track to brake the car, the men work in a heavily timbered area. The men are loading large pieces called lump.

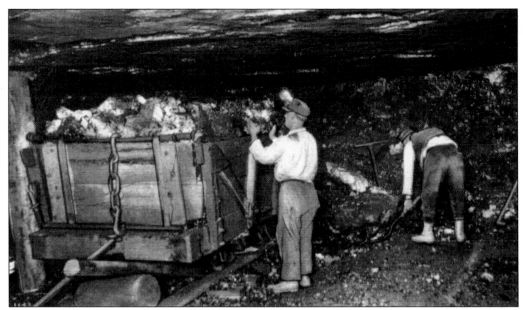

A miner and laborer load a car at the face. Note how the track is run up to the face. Instead of using a sprag to brake the car, the miner has placed a large piece of lumber under the front of the car.

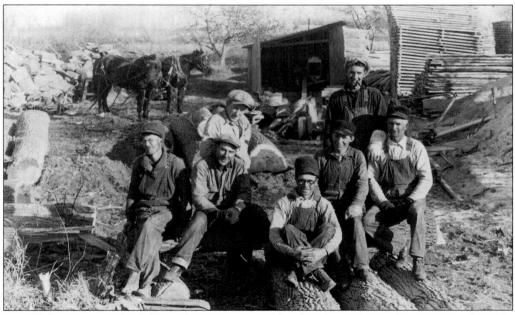

One of the many needs of the coal miner was good hard timber to be used as props. In the early 20th century, good timber was hard to come by, as most of the collieries had used up the local supplies. The mining companies bought timber from suppliers. This is a photograph of a mill that supplied timber for the mines.

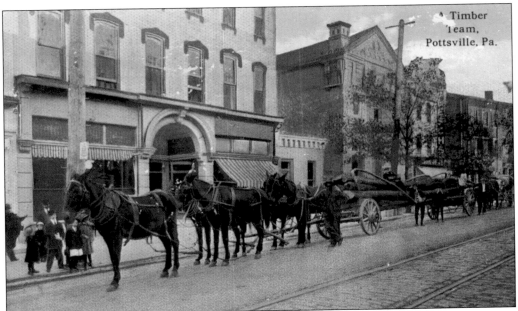

After the timber was purchased, it had to be hauled to the colliery, where it would be placed in the prop yard or in the storage yard for uncut timber. This scene was quite common throughout the anthracite region. Due to the heavy weight, this load required five mules—four in tandem and one in the lead.

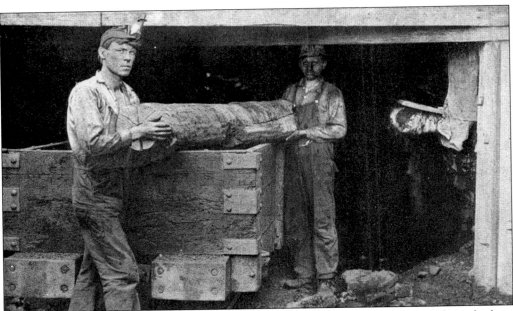

When the miners needed a prop or collar for roof support, they had to measure and cut the long length of timber to the size required. The timber was usually loaded on a flatcar or empty coal car and hauled into the mine, where it was placed. All handling of the timbers was done by hand, using a tool called a timber dog, a metal handhold hammered into the timber.

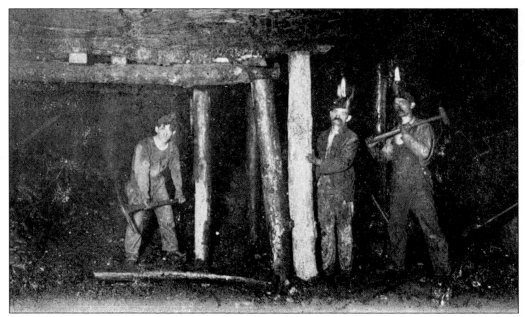

Setting the props, one miner places the prop under the roof while the laborer digs out the dirt with his pick. The other man waits to hammer in a wedge to make a tight fit between the roof and floor.

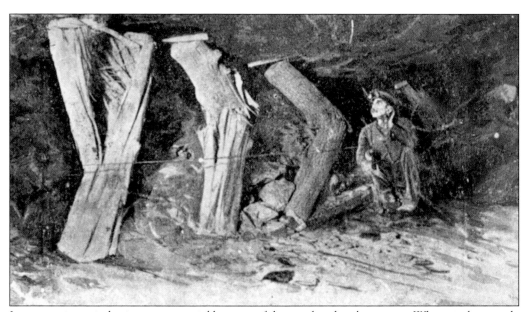

In some mines, timbering was essential because of the overhead rock pressure. When timbers made a creaking or cracking sound, the miners said the roof was pressing. A sure sign of danger was split or broken props. It was claimed that wet timber gave better support than dry timber did.

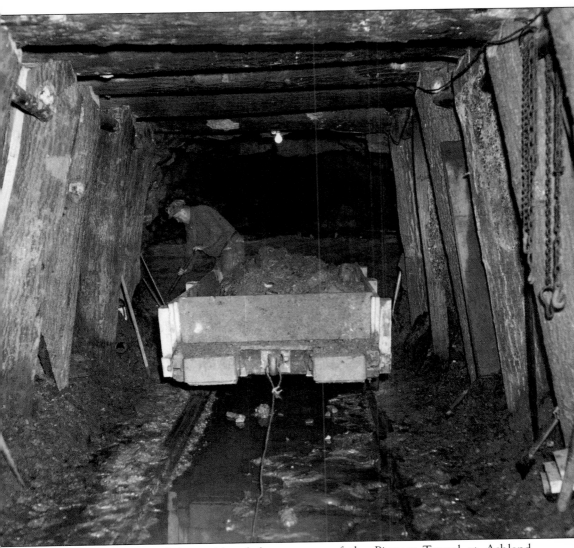

This is a superb view of the inside of the gangway of the Pioneer Tunnel at Ashland, Pennsylvania, and the timbering inside a mine. Note the props leading up the sides. The collars lay across the top. When the roof was hard and the bottom soft, it presented the miner with the worst case for timbering. Note, too, the ever present moisture inside a working mine.

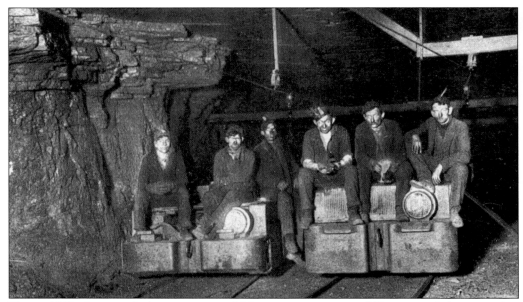

This c. 1909 photograph shows miners and laborers sitting on two different-sized electric mules. According to mine laws, no electric trolley wire was permitted in a gaseous mine, except where there was sufficient air flow from the outside. Note the overhead trolley wire.

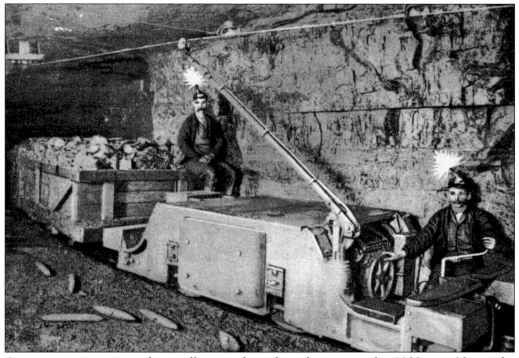

A miner operator gets ready to pull a trip of cars from the mine in this 1908 view. Notice the sprags lying on the ground and the overhead trolley wire. Many men, boys, and animals were electrocuted in the mines by coming in contact with the overhead wire.

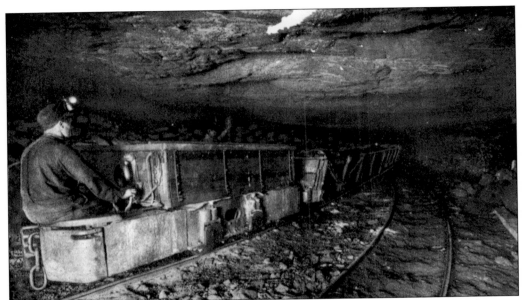

The operator is getting ready to pull out a trip of loaded cars. Note there is no overhead wire or trolley. This type of electric locomotive uses a storage battery to supply the power, much safer in a gaseous mine.

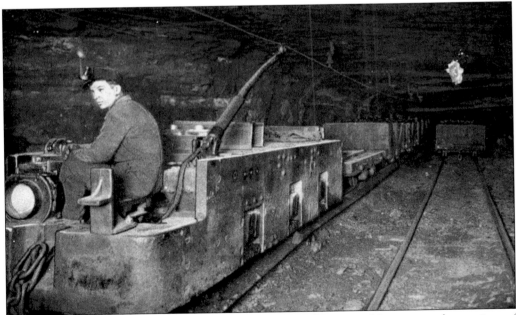

Most electric mules in the mines were built very low so they were able to enter the sections of a mine where the roof was low to the ground.

47

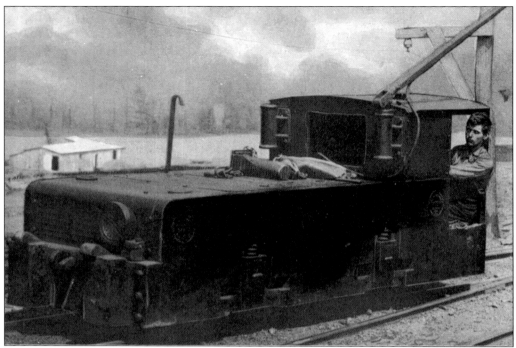

This type of electric locomotive was used in and around the outside of the mine. Note that it has an enclosed operator's station.

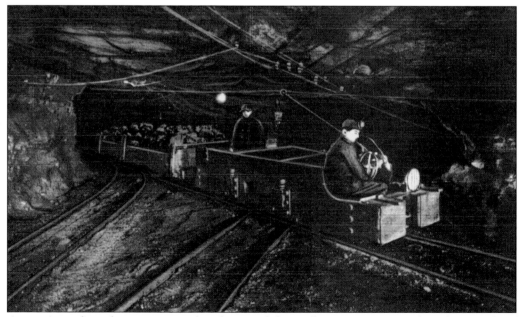

As concerns for safety were met, the placing of the trolley wire was moved to the outside of the gangway and the trolley pole was moved to the side of the car, making it safer for the men working inside.

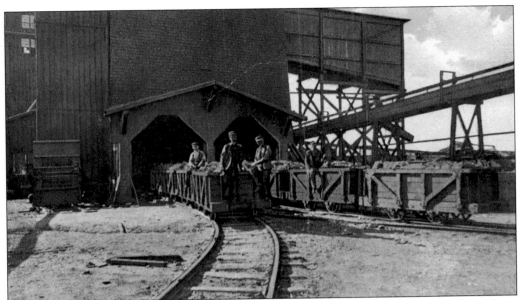

After the cars were taken from the mine, they were brought to the base of the breaker, where they were either pulled or hoisted to the top of the breaker. The coal was dumped down into the chutes to be separated.

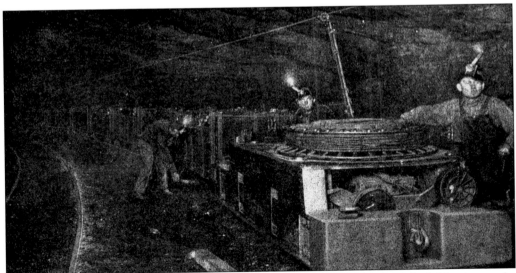

The electric mule had the ability to pull many more cars than the ever faithful mine mule, bringing about the end of the mules' usefulness in large colliery operations.

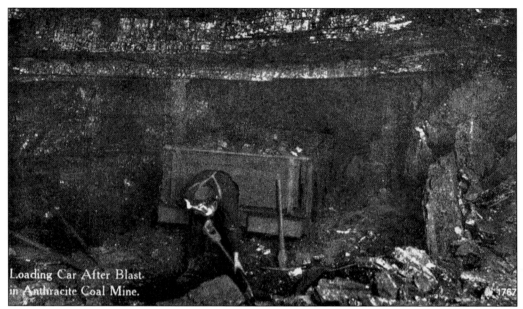

Pictured is another view of a laborer loading coal at the face. The bullwork associated with coal mining came when the coal had to be loaded into the empty cars.

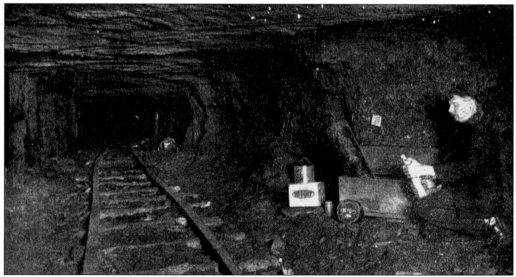

The miner is preparing a charge to be used for blasting out the coal. By mine law, the powder and fuse had to be kept a safe distance from a shot that was to be fired. Note that the miner has his powder in the round can and that the open flame on his cap is not lit.

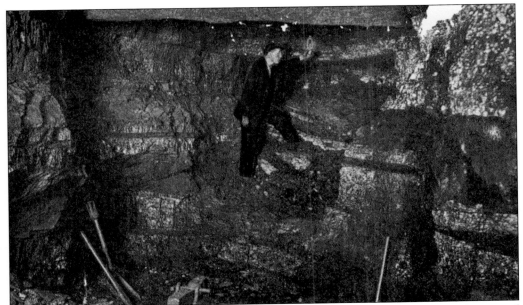

Using his Davy lamp, the fire boss tests for gas called fire damp, which is highly explosive and hangs near the roof of the mine. "I am a fire boss of renown. / At 3 each morning / I make my usual round. / I walk the open cross cuts / to get to the face / to find how much gas there is / in every miner's place." —Old mining ballad.

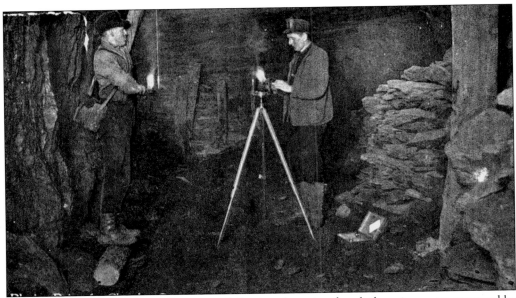

When miners were driving a gangway or following the vein of coal, the mines were surveyed by experienced company surveyors. Here, two men use the tools of the trade.

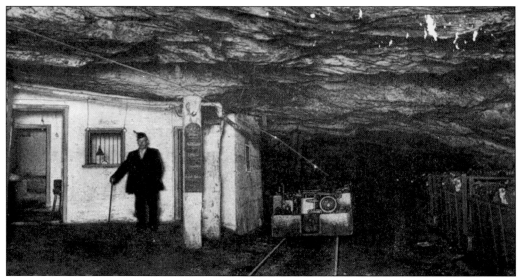

Built deep inside the mine is the fire boss' office. Every morning, he carefully inspected every working place and all the ventilating equipment for proper air flow and the presence of any dangerous gases.

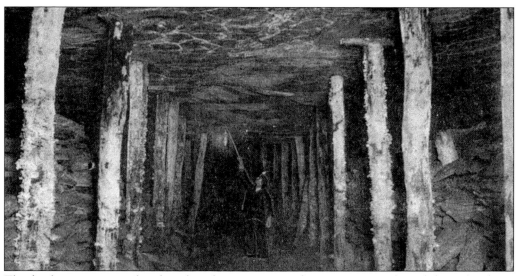

The fire boss examines abandoned workings in a mine for gas, using a pole with his safety lamp attached to reach the highest portion of the gangway. Note the mold, mildew, and fungus growing on the old timbers.

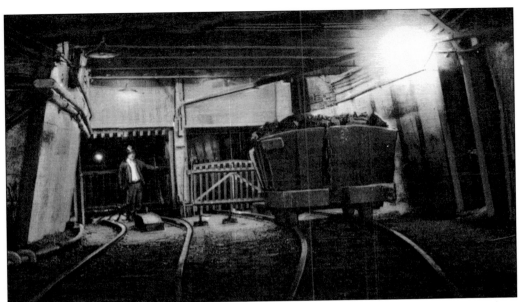

This view from the bottom of the shaft shows the loaded car ready to be hoisted to the surface. The man standing by the open gate is the footman. His duties were to attend to the signals used for lowering and hoisting the cars and employees. He reported directly to the mine foreman.

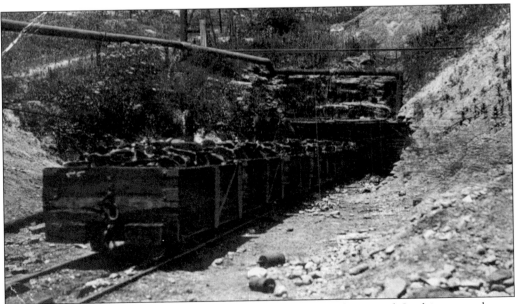

Depending upon the type of mine, there were different types of cars used. In this scene, the car is attached by a center point that was attached by a spreader chain to a wire rope.

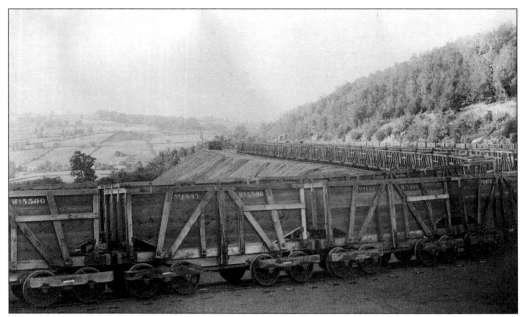

This image offers an excellent view of the early type of coal cars used for hauling the processed coal from the breaker to market. Note their wooden construction.

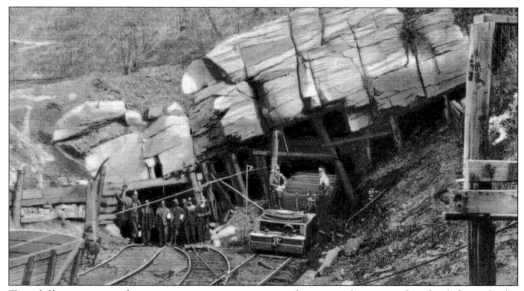

Two different types of entrances into one mine are shown in this view. On the left, with the men in front, is a slope with the hoisting rope going out and up to the engine house. The opening on the right is a tunnel using an electric mule with overhead trolley wire.

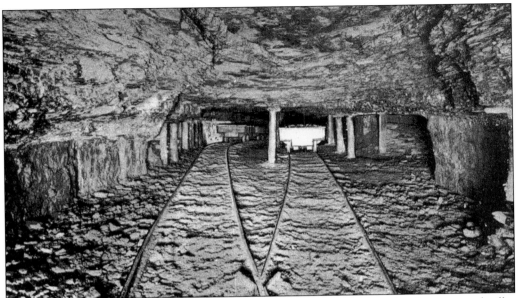

This scene shows a double-tracked gangway. The type of mining being used is the room-and-pillar method. On the right is a pillar of coal separating the rooms.

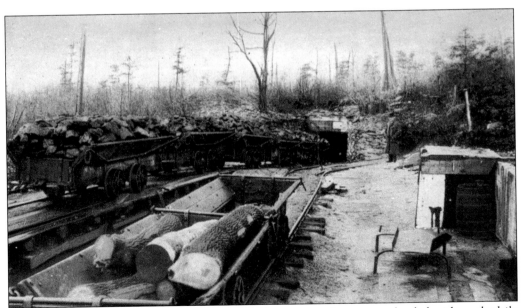

In this slope mine, low winged cars are used. The cars coming out are loaded with coal while the one car sitting on the turnoff is loaded with timber. There were many styles of cars used in the anthracite mines.

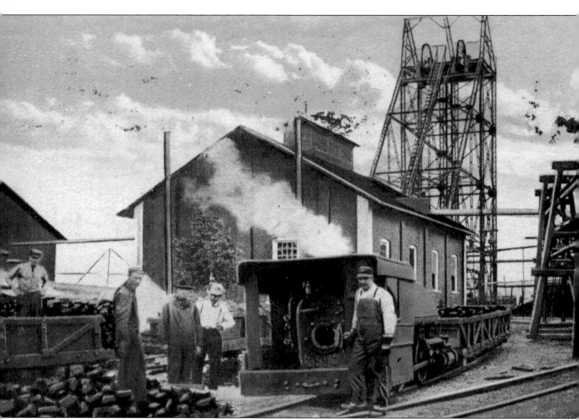

This small lokie is used in the yard to haul the loaded cars from the shaft to the breaker. The head frame in the distance is where the entrance for the shaft would be located. Note the large lump coal used in the burner of the lokie. Cars were hauled from the mine entrance to the breaker, where they were stored until hoisted to the top.

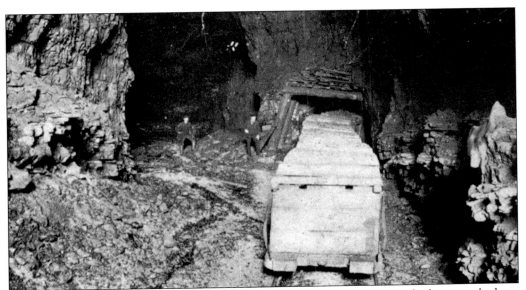

This is an unusual-looking gangway and chamber deep inside a mine. Notice the large, worked-out open room and the timbered gangway with the cars coming out.

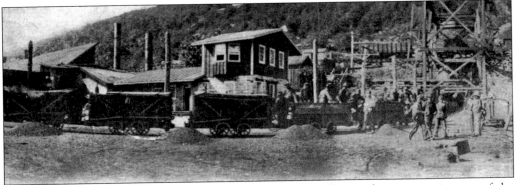

Cars are shown coming out of the Williamstown tunnel. Observe the men getting out of the gunboat car, which was used specifically for transporting men and equipment.

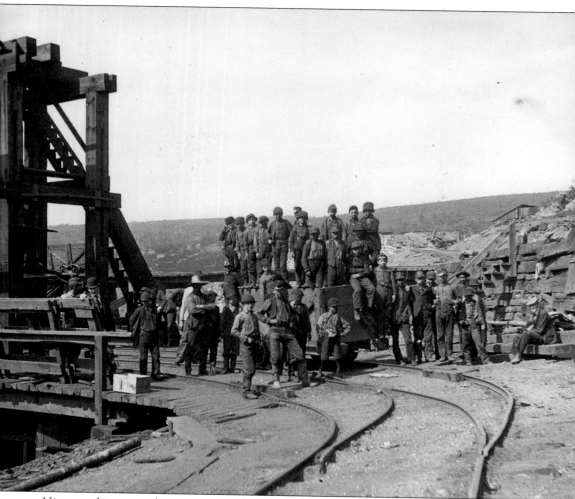

Nippers, drivers, and spraggers are shown at the entrance to the William Penn Colliery, in Pottsville, Pennsylvania. "Now don't despise the miner lad / who burrows like the mole / Buried alive / from morn to night, / To delve for household coal / nay miner lad neer blush for it / though black thy face be as the pit." —Old miner's refrain, Pottsville, 1848. (Courtesy Schuylkill County Historical Society.)

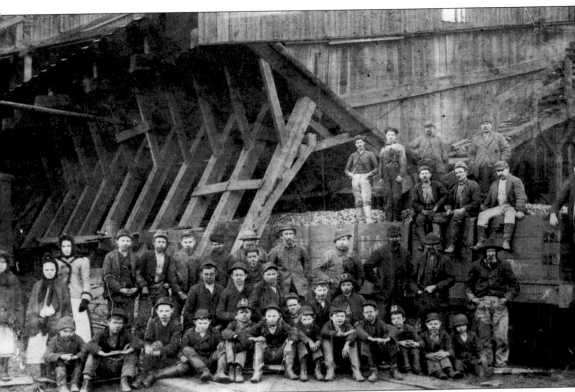

Miners and boys are shown at the base of the Thompson Colliery breaker in 1893. Note the three young girls on the left, probably visiting the area. By custom and law, no females worked in the early anthracite coal mines, unlike Europe, where young and old women worked in and around the coal pits. (Courtesy Schuylkill County Historical Society.)

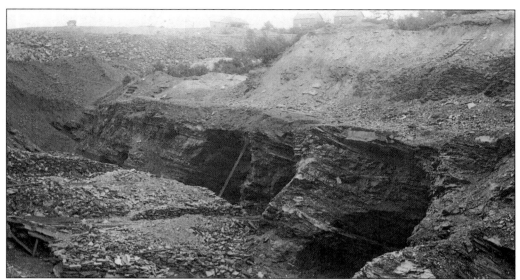

This photograph of a stripped out area of the Cranberry Coal Company shows the vein of coal and the old workings of rooms and pillars that were once underground.

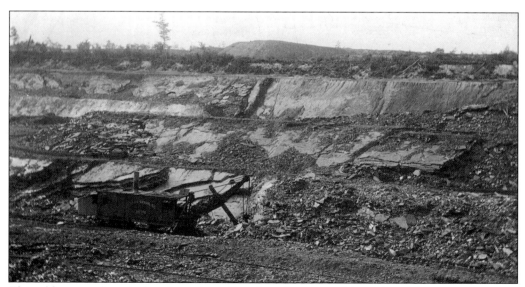

This old steam shovel placed on the railroad track was used in strip mining near Lattimer, Pennsylvania, in Luzerene County. Note the different excavated levels as they followed the veins of coal.

Three

MULES, DRIVERS, AND SPRAGGERS

The mule has been associated with anthracite coal mining since its inception in the mine. Many stories, legends, and myths surround the famous mine mule. For over a century, it was the mainstay of the mine haulage system. The mule was used for its strength and surefootedness. It was less susceptible to sickness than the horse was. With the advent of electricity, the mule was slowly removed from the mines.

Mules also possessed another quality that the miner and driver both respected—its strange instinct for self preservation. Many mules led miners to safety with their foreboding of impending disaster. Some mules worked and lived underground for many months, some even for years, never seeing the light of day. Others were brought to the surface daily. While staying underground, they lived in well-kept stalls. They were fed twice a day and generally received good care. It was said that some companies took better care of the mules than of the men. Abusing or injuring a mule could cost the miner or driver his job. The boys who worked with mules were called the drivers. This job was most coveted in the mines for a young man. Mules and drivers were together for 8 to 10 hours a day, and a great love-hate relationship developed between them. Mules were used in the anthracite mines well into the late 1950s. They were eventually replaced by the electric mine motors called electric mules.

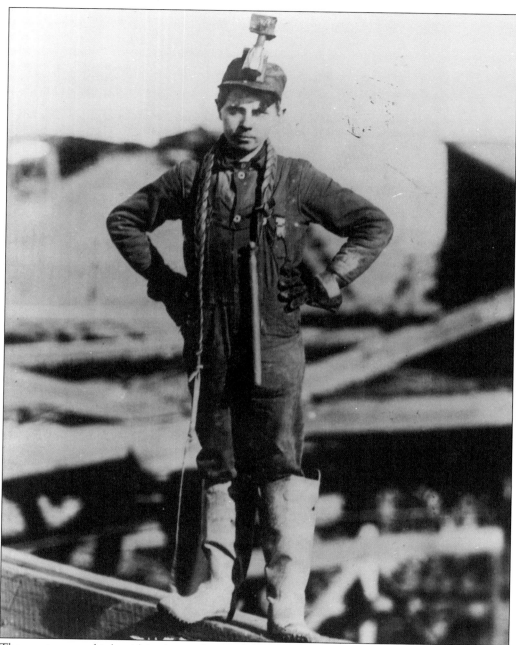

The most coveted job within the workings of the mine for a young man was that of the driver, the boy who drove the mules. He was responsible for their care and upkeep. Driver boys usually ranged in age from about 15 to their twenties. This photograph shows a driver boy and how he looked in the 19th century or early 20th century. Note that he carries a well-worn handmade cut-plait whip around his neck, the symbol of the driver.

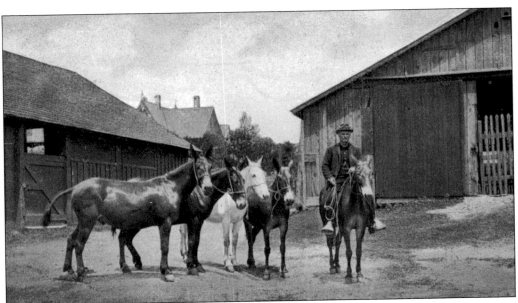

Thousands of mules worked in the anthracite coal fields. New mules for the mines were purchased by the company from brokers, who usually bought the mules from farms in Tennessee and Kentucky. These four healthy mules would soon make their way underground and share in the dangers of coal mining along with the men and boys who worked in the dark, damp, and dust of the anthracite mine.

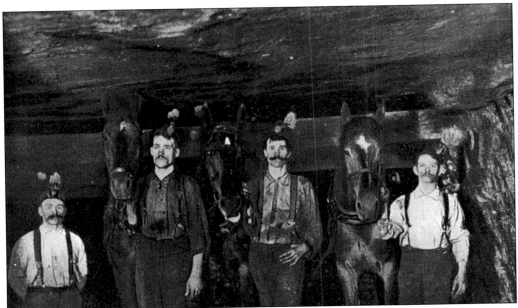

In this view of mules and their drivers, note how the large mule's ears on the right just touch the roof of the mine. The mule could feel his way along a dark gangway by the touch of his sensitive ears. However, their ears could also touch an overhead trolley wire when electricity and mules were used together.

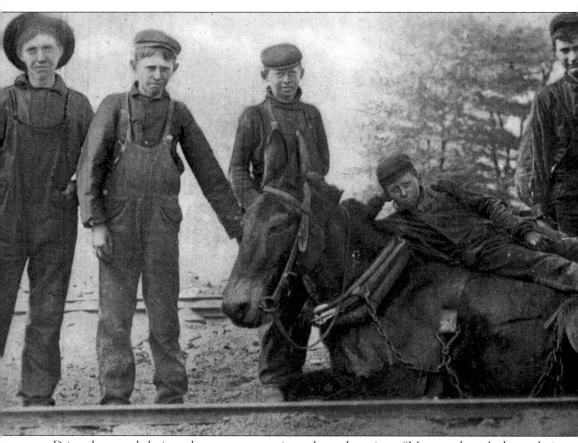
Driver boys and their mules were companions about the mines. "My sweetheart's the mule in the mines. I drive her without reins or lines. On the bumper I sit, and tobacco I spit, all over my sweetheart's behind." —The anthem of the driver boys.

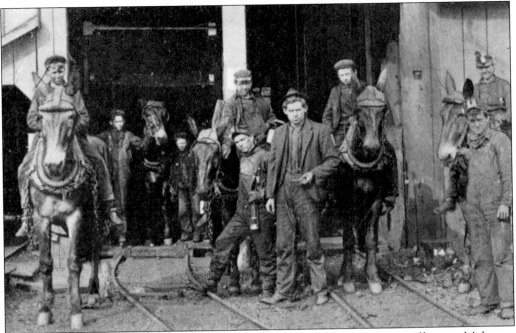

This view shows mules and drivers coming to the surface at a shaft near a colliery at Mahanoy City, Pennsylvania. The mules are wearing leather bonnets and still have their hames and collars on. They will be taken to the stable for feeding and water.

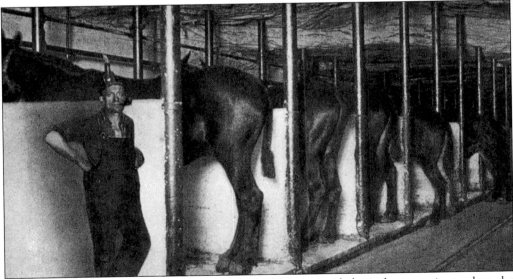

According to mine law, no mule or stable could be provided inside any mine unless the space occupied was excavated in solid strata rock, slate, or coal. The stable had to be built of incombustible material. Wood could be used only for the flooring of the stable.

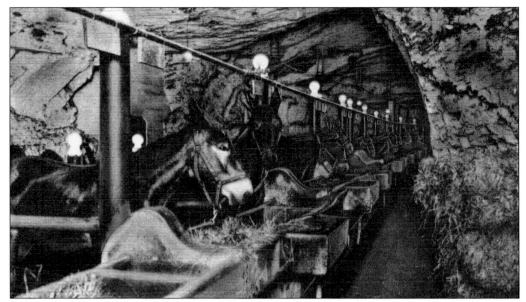

Rules regarding mule stables underground were strictly enforced. One such rule for the use of hay was that no hay or straw could be taken underground unless it was made into compact bales. The hay was to be kept in a storage area away from the stables. No open flame was allowed in the stable.

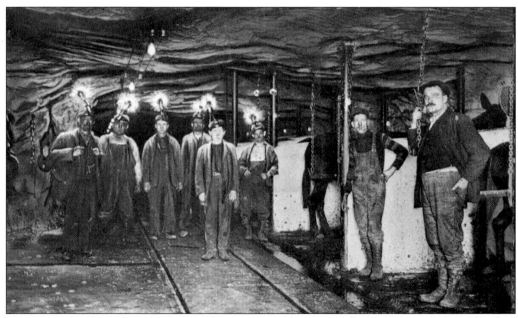

This is a view of a mule stable built right into the rock strata of the mine. It includes individual stalls for each mule. Most stables were located near the foot of the shaft or the entrance to the main gangway for easy access.

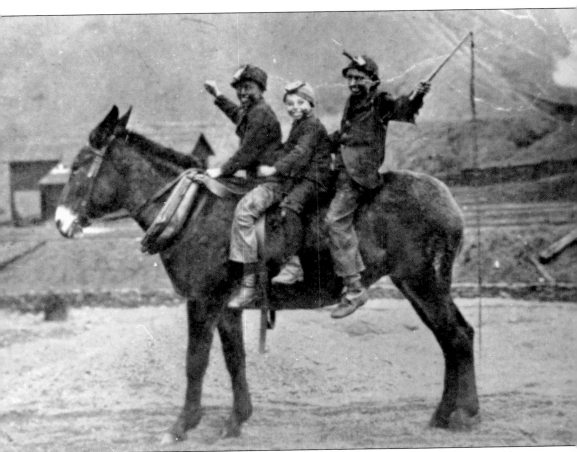

There was an amazing love-hate relationship between the driver boys and their mules. Here, three young lads ride their mule in a moment of glee. As much as the boys loved their mules, some mules, it was said, preferred certain driver boys.

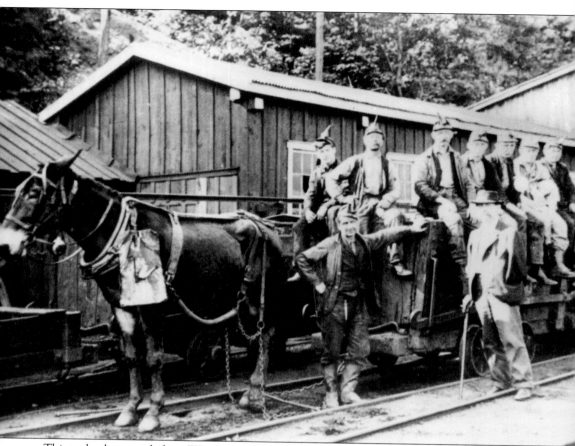

This early photograph from Wiconisco, Pennsylvania, shows a mule ready to pull two cars. Observe the lamp hanging on the mule's front shoulder. The mule used the same style open-flame lamps as the miner. The pad hanging on the collar kept the open-flame lamp from burning the mule.

One of the many dangers with working with mules included a mule that was stubborn or cantankerous. Many boys and miners were killed or severely injured by a mule giving you "both barrels," as the boys called it, otherwise known as a full kick to the rear.

Shown is a double view of the workings of an anthracite mine. The top picture depicts a cage about to be lowered. The bottom image shows a driver and his mule rigged for pulling. Observe how the mule harness is applied for the job.

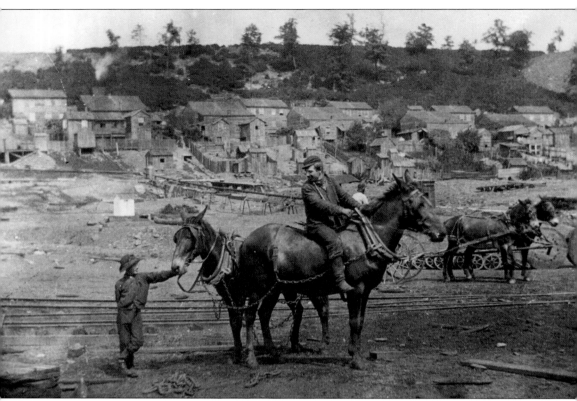

This photograph shows two drivers and two mules at the Morea Colliery. The patch town of Morea is in the background. The two mules are rigged for a tandem pull. Note the car wheels lying around, the u-bolts for attaching the spreader chains to the cars, and the sprags. Also note that the mounted driver is using a bridle, used only outside of a mine. His cut-plait whip is hanging around his neck. It required a great amount of strength to get a four-ton loaded coal car moving from a dead stop, but the average mule could pull up to three loaded cars.

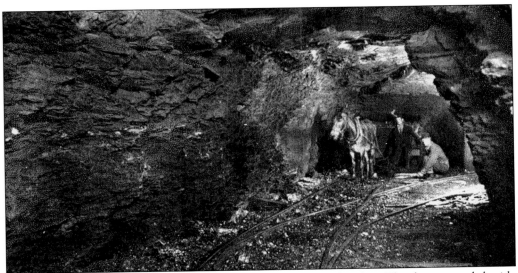

In this picture, a mule is ready to pull a loaded car from the chamber. The driver stands beside the mule while the spragger removes the sprags so the car will be free to roll. The driver commanded the mule by voice commands: "Ghee" meant to turn right, "Wa Ha," turn left.

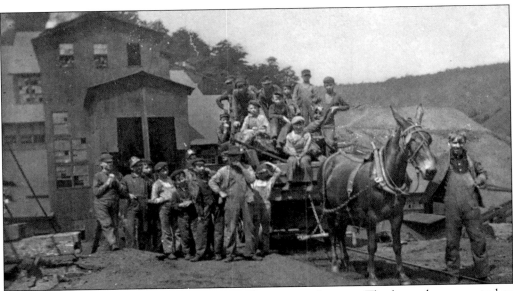

This was a common scene when a photographer was in the area. The boys always wanted to pose with their mules. This mule is being led by a bridle. The bridle was used on the mules that worked on the outside, in the yard, or on the dump.

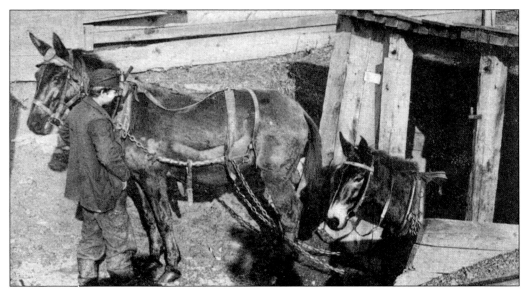

The driver and the mule were together for up to 8 to 10 hours a day. After work, the driver put the mule in the stable. He was required to feed and groom the mule. In the morning, the driver would be one of the first in the mine. He would go to his stable to get his mule hitched up and ready to pull in the empty cars.

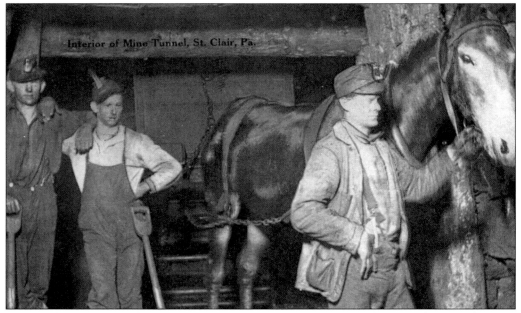

A driver holds his mule by the halter. It said that some mules actually enjoyed the work. Some would run races through the gangways with the drivers when in a playful mood. Others enjoyed sharing the miner's lunch or a pinch of tobacco, which they became addicted to. They also liked to chew on fine pieces of coal and swallow it.

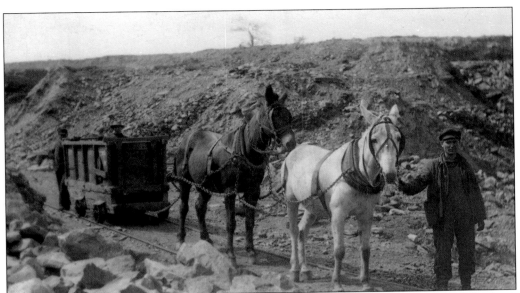

The number of cars or their weight decided how many mules would be needed to haul the load. This photograph shows two mules hitched in tandem at the dump. Mules, like horses, came in many colors—bays, browns, blacks, and even some whites.

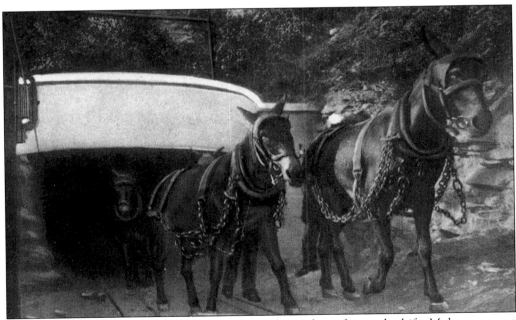

At some collieries, the mules were brought to the surface after each shift. Mules were not allowed to be worked on back-to-back shifts. It was common to cover the mule's head and eyes with burlap when bringing it to the surface to protect its eyes from the bright sunlight.

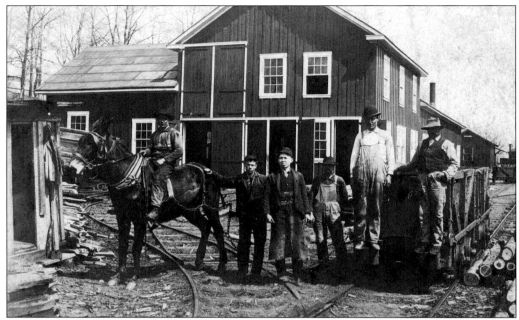

Photographed at the Lytle Colliery near Minersville, Pennsylvania, a mule is rigged for work with its driver. Note the men standing near the car. They are outside workers at the colliery—possibly carpenters, blacksmiths, or yard workers.

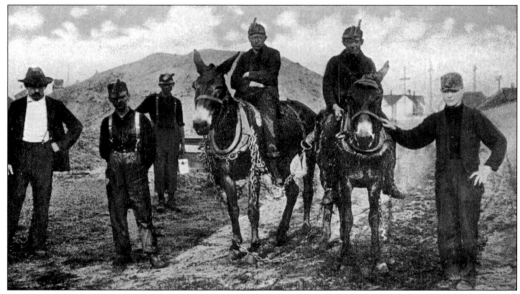

Driver boys are shown with their mules. The driver boy had more freedoms than any of the other young colliery workers. According to legend, the driver boys were always out for mischief. It was forbidden to ride on the mules bareback because of the danger. As this photograph shows, however, the boys did it all the time.

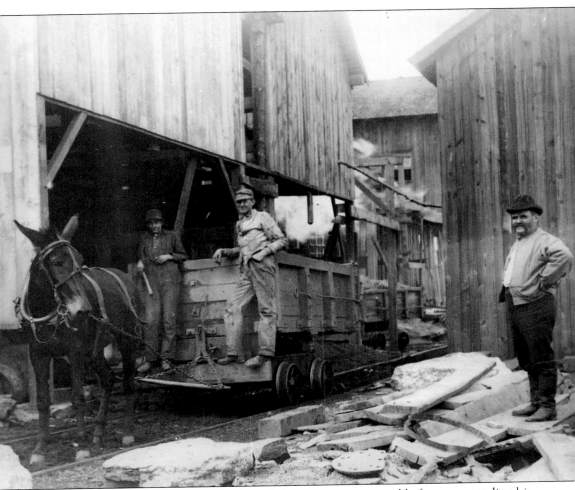

Standing on the bumper, the driver waits until the sprags are removed before commanding his mule to pull the car. The driver usually sat or stood on the bumper of the car while in motion. The collars used on the mules had to be kept oiled and cleaned to ensure proper fit and to avoid any rubbing.

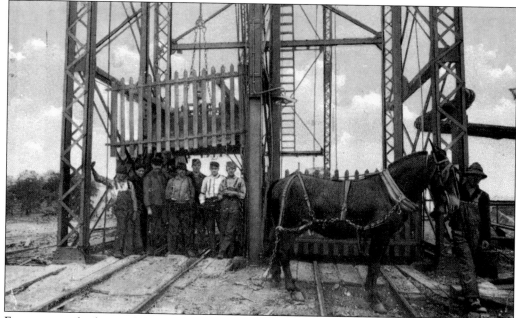

For reasons of safety and the size of the animals, mules were always lowered into a shaft singly. This mule is ready to be lowered into the shaft. Hundreds of thousands of mules worked in the anthracite mines of Pennsylvania. In 1916 alone, more than 12,300 mules worked in 25 anthracite coal districts.

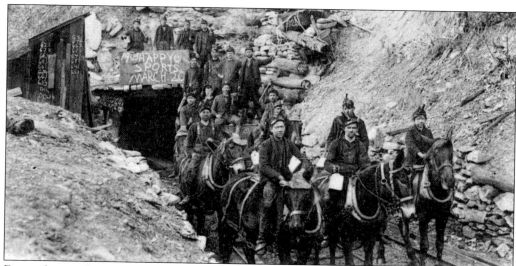

Driver boys ride their mules out of a tunnel. It was said that when the mules who were underground for months or years came to the surface, they would tremble with excitement and go dashing about the paddock, kicking and baying as if they were mad. Mules actively worked in the mines from the 1850s until the late 1950s. Finally, in 1964, a law was written that stopped the usage of animals in mines.

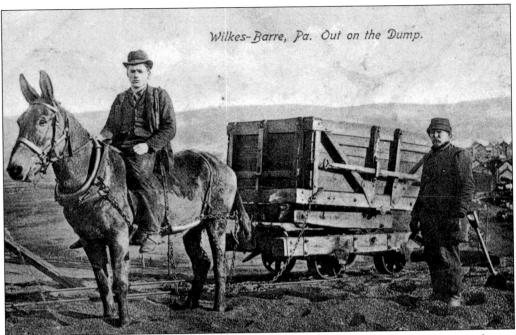

Wilkes-Barre, Pa. Out on the Dump.

Usually, older mules worked on the colliery slate and culm banks. The best mine mule was judged by his age; two years old was the best age to start to work. Large ears and small feet indicated a hardier mule. Very large mules were not desired. A mule in good health at age four (with proper treatment and barring any serious injury) could live for 18 years. Most of the drivers preferred mares.

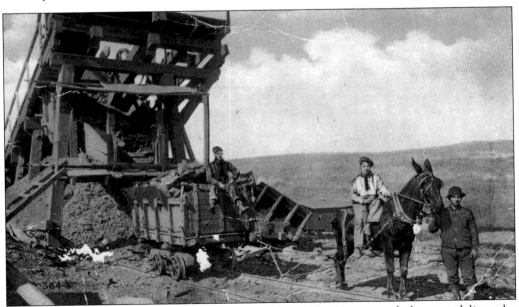

Many mules were used outside the mines as well as inside. Here, a mule has just delivered a load of slate to the dump. Many of the large remaining coal banks in the anthracite region were started by mules hauling the waste out of the mines.

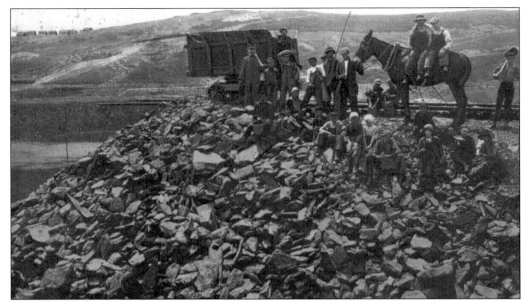

Slate pickers, the dump car, and their mule are shown on a rock pile near the Shenandoah City Colliery, Shenandoah, Pennsylvania. Note how the track was run to the end of the bank. The refuse was dumped over the edge, sometimes creating piles hundreds of feet high.

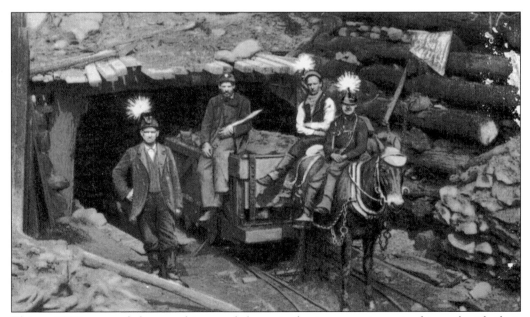

This c. 1909 postcard shows a driver and three tired miners coming out of tunnel with their mule rigged for a single car pull. The boy sitting on the car is holding a sprag, and the mule is wearing a leather safety bonnet.

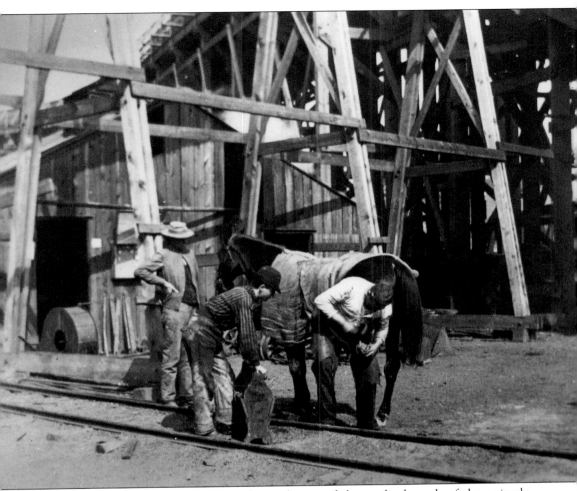

Every large colliery had a veterinarian who took care of the medical needs of the animals. The collieries also had a blacksmith shop in which a farrier would take care of the shoeing of the mules. Mule shoes were somewhat different than horseshoes. Some contained a flange off to one side to help the mule dig in and get traction when pulling a heavy load. If a mule was sluggish or his appetite was poor, it was common to give him a small quantity of saltpeter or some powdered sulphur to help him along.

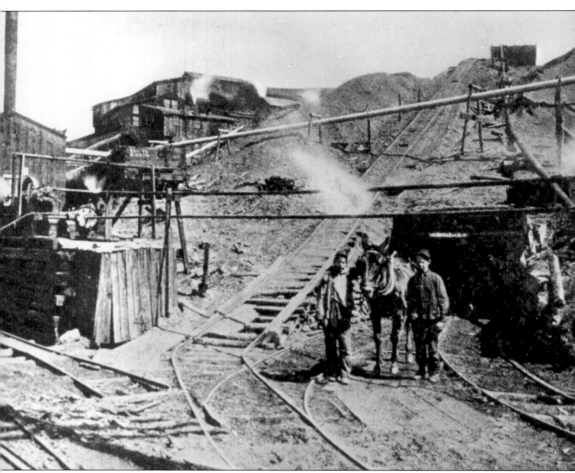

At the east Lehigh tunnel, two driver boys stand with their mule at the entrance of the tunnel. The breaker is in the background, along with the long section of track leading up to the culm bank, where all the refuse was dumped. Driver boys were required to maintain a quota for the number of cars they brought in and out. They were also responsible for the safety of the mule. When taking his trip down a steep grade, the driver had to make sure that the car did not ride up on the mule's hind legs. The driver usually had an assistant to take care of the breaking. He was called a runner or spragger.

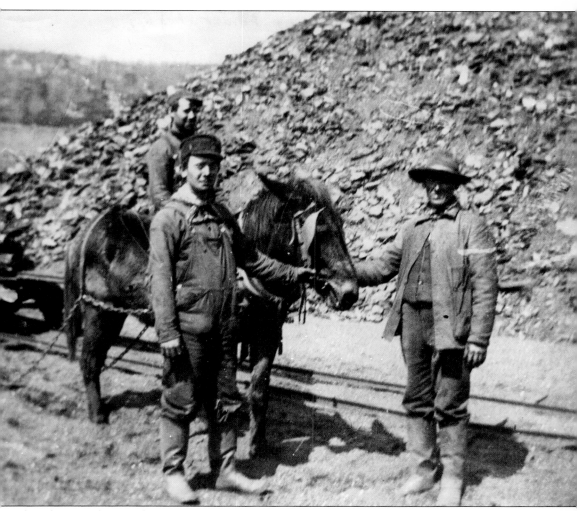

This photograph was taken near the Kaska William Colliery, near Kaska, Pennsylvania. Three outside workers, along with a small mule, haul refuse to a dry-waste dump. Waste was divided into two classes—waste coming from dry breakers and waste coming from wet breakers. In some collieries, waste was divided into rock, slate, and culm banks.

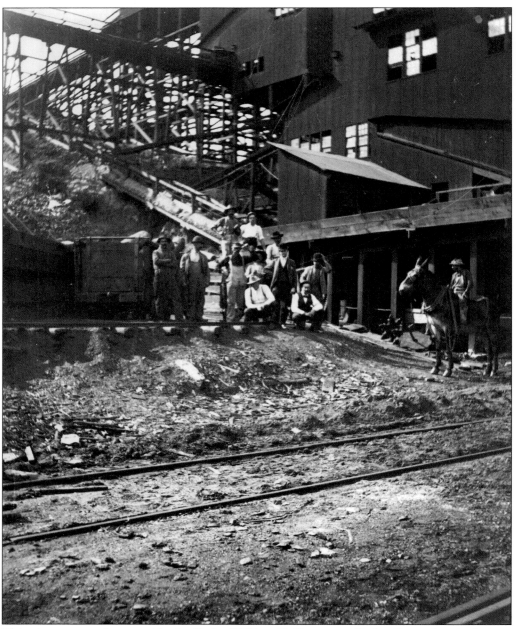

This picture was taken outside the Kaska William Colliery, near Kaska, Pennsylvania. It is an excellent example of the working colliery, showing some mine officials, miners, loaded cars, and the ever present mine mule with the driver boy mounted. (Courtesy Schuylkill County Historical Society.)

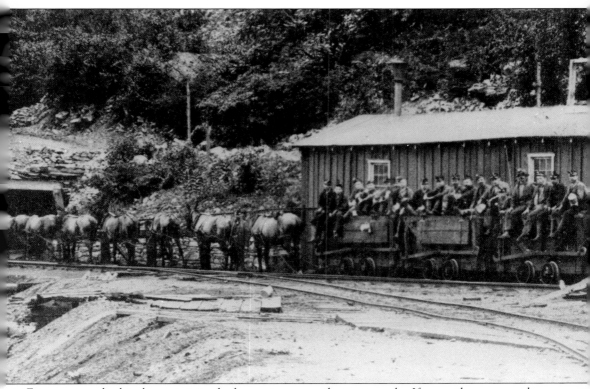

Extreme care had to be maintained when using more than one mule. If more than one mule was used, they were always teamed in tandem. A driver could never team a fast mule with a slow one or a very nervous mule with one that was calm. This photograph is definitely a staged picture, as there would be many problems associated with this team.

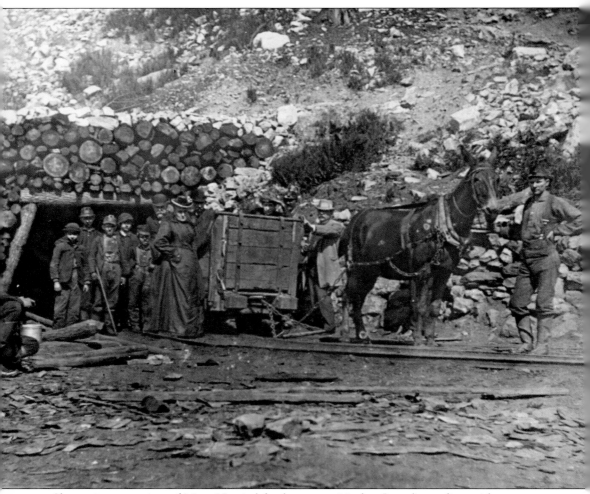
Shown is a rare view of Mary Harris (also known as Mother Jones) standing with some young driver boys and a mule near the entrance to an anthracite tunnel. Mother Jones fought for the right of the children who worked in the mines and the breakers.

One

THE BREAKER BOYS AND THE BREAKERS

In 1894, Stephen Crane made a trip into the anthracite coal region of Pennsylvania and wrote an article for *McClure's*. In the article, he describes what he saw:

> The breakers squatted upon the hillsides and in the valley like enormous preying monsters, eating of the sunshine, the grass, the green leaves. The smoke from their nostrils had ravaged the air of coolness and fragrance. All that remained of vegetation looked dark, miserable, half strangled. A breaker loomed above us, a huge and towering frame of blackened wood. It ended in a little curious peak, and upon its sides there was a profusion of windows appearing at strange and unexpected points. Through occasional doors one could see the flash of whirring machinery. At the top of the breaker men were dumping the coal into chutes. The huge lumps of coal slid slowly on their journey down through the building. Great teeth on revolving cylinders caught them and chewed them. With terrible appetite this huge and hideous monster sat imperturbably munching coal, grinding its mammoth jaws with unearthly and monotonous uproar. In a large room sat little slate-pickers. The floor slanted at an angle of forty-five degrees, and the coal, having been masticated by the great teeth, was streaming sluggishly in long iron troughs. The boys sat straddling these troughs. . . . There were five or six of them, one above another, over each trough. The coal is expected to be fairly pure after it passes the final boy.

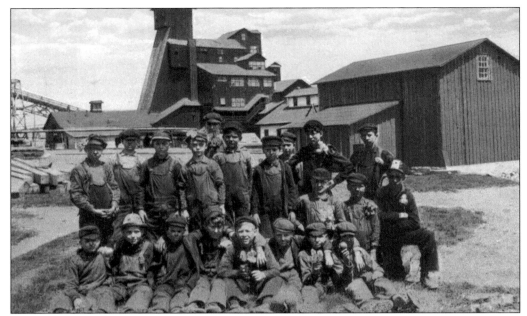

Breaker boys pose near an anthracite breaker. Sometimes, the boys would have a sit-down strike, leaving the breaker idle and causing grief among their fathers who were the miners. The bosses would frequently chase the boys back to work with whips.

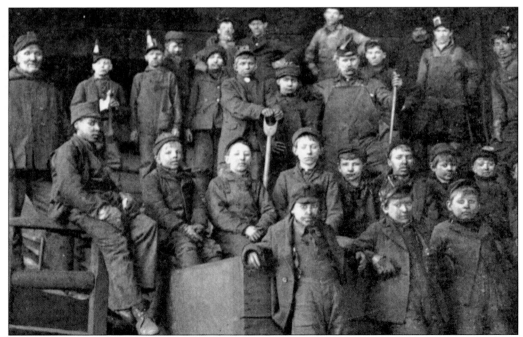

"I am a little collier lad / hard working all the day / from early morn / till late at night / no time I have to play / down in the bowels of the earth / where no bright sun rays shine / you'll find me busy at my work / a white slave of the mines." —Samuel W. Boyd, Wilkes Barre, 1891.

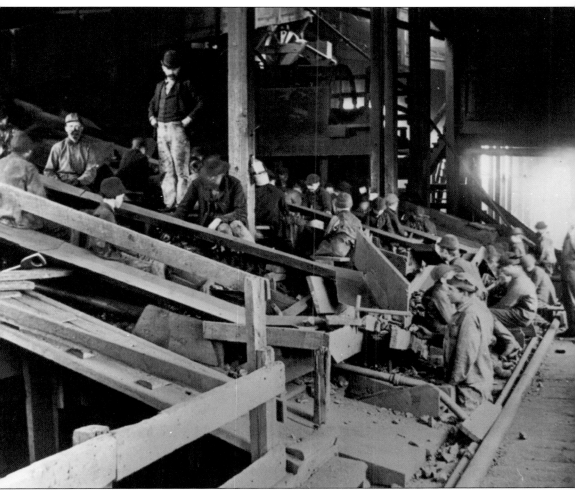

These young boys, at work in the breaker screen room sat on wooden benches usually with a leg raised so the coal could pass beneath their legs. Their backs were arched from the constant bending. The dust was so thick that it could be cut with a stick. Some boys had to wear a lighted lamp on their hats just to see the boy sitting beside them. They chewed tobacco, trying to keep the coal dust out of their mouths. Enduring all the hardships of their work, the breaker boys had to fear the dreaded chute boss, who roamed the breaker looking for the boy who did not pick fast enough or who talked too much. A quick smack on the back with a stick or leather belt got the boy's attention.

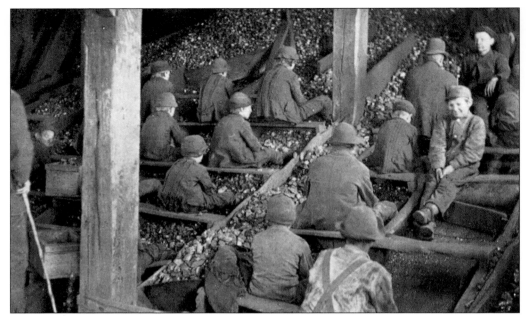

Young slate pickers sit above the troughs of running coal and remove the slate and rock. Some of these boys started working in the breakers when they were 9 or 10 years of age. Their fingertips were worked raw and bloody, giving them the nickname "red tips."

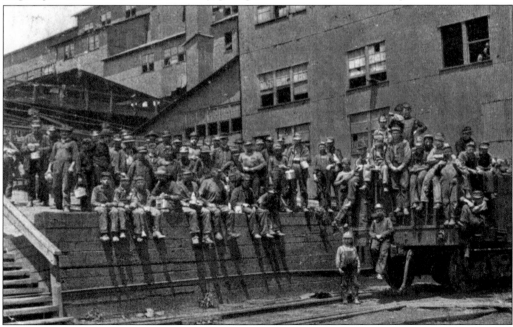

During lunch, the boys would sometimes play baseball or pull practical jokes on new breaker boys. At the end of their shift, the boys would rundown the narrow wooden stairways that ran on the outside of the breaker. Faces black and bone tired, they went home and had a bath in the family wooden tub. Like any youth of old, they would eat their supper and run off for some evening play before returning before dawn to their tasks.

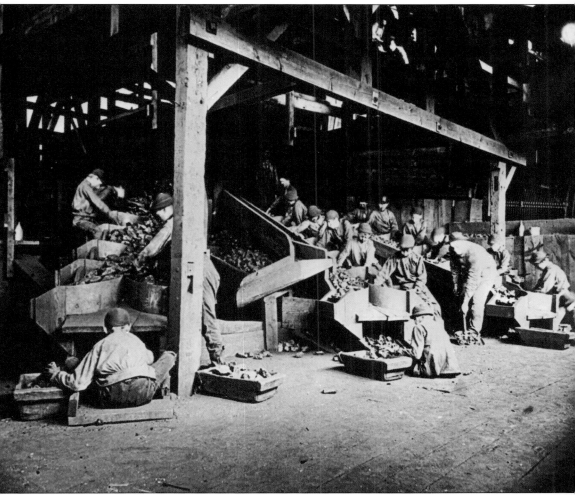

This photograph shows the inside of a breaker with the young breaker boys hard at work picking slate and rock from the crushed coal. The photograph was taken before the labor act of 1885, which set a minimum age of 12 years old for working in a coal mine. This law was often overlooked for the young boys of 9 or 10 who worked in the dust- and noise-filled breakers.

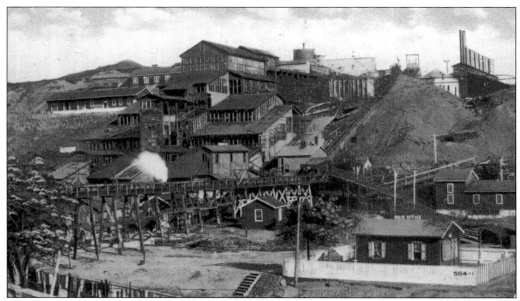

The complete operation of a coal mine plant was called the colliery. It embraced both the surface and underground workings. The above-ground operations included the hoisting engine house, the boiler houses, the breaker, the blacksmith and carpenter shops, the railroad tracks, the wash house, supply house, powder house, water tanks, culm and rock banks, and the mule stables.

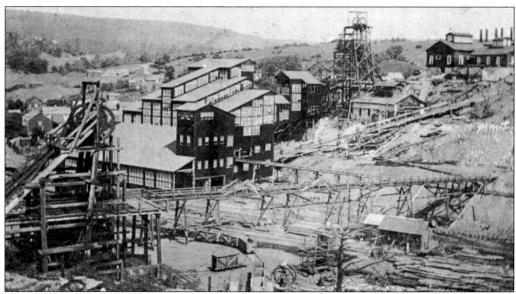

This photograph of the Wadesville Colliery, near St. Clair, Pennsylvania, shows the breaker located between two types of entrances. The head frame for the shaft is to the right, and the head frame for the slopes is to the lower left. The boiler house, with its six smoke stacks, is located well up on the hill.

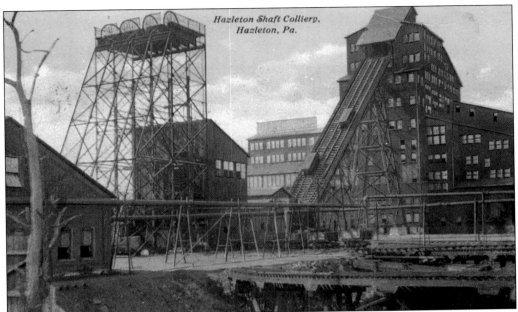

In this view, the head frame is located over top of the Hazelton Shaft Colliery in Hazelton, Pennsylvania. The hoisting method of a shaft was done by a vertical or an inclined hoist. Anthracite mine law stated that no inflammable structure (other than a frame to sustain pulleys or sheaves) could be erected over an opening of a mine connecting with the underground workings.

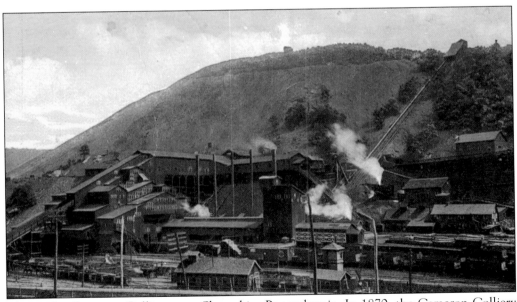

This is the Cameron Colliery near Shamokin, Pennsylvania. In 1870, the Cameron Colliery had 3 drift entrances, 3 slopes, a breaker, and 21 steam boilers. It was unlawful to place any steam boiler nearer than 100 feet from the breaker or any place where men were employed in preparation of the coal.

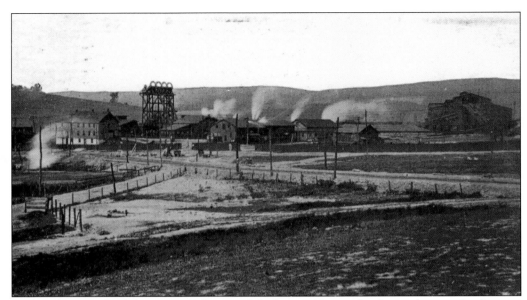

In this photograph of the No. 7 Colliery and shaft, near Nanticoke, Pennsylvania, the distance used for the breaker from the mine entrance is very evident. The mine entrance is located under the large structure to the left, called a head frame.

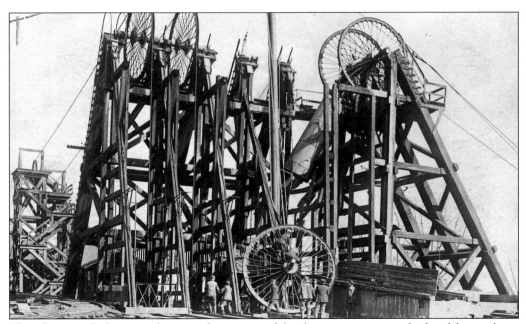

This photograph shows workmen replacing one of the sheaves on a triangular head frame above the shaft at the Lytle Colliery, in Minersville, Pennsylvania. There were three types of head frames used in the anthracite region—triangular, square upright, and upright frames.

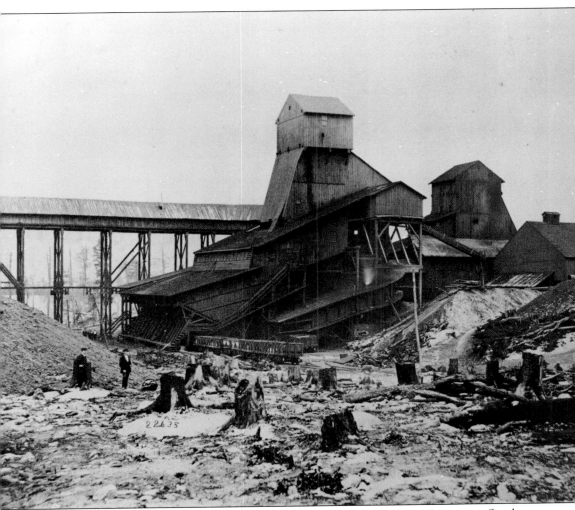

The Kohinoor Colliery in Shenandoah, Pennsylvania, is shown in this view. It is just as Stephen Crane described—an enormous preying monster, blackened wood, and a curious little peak on its top. In the anthracite coal fields of Pennsylvania, thousands of these breakers once dotted the landscape. In the 1890s, there were more than 280 breakers in the anthracite coal fields. Today, there are fewer than 10. Some were small operations. Others were major undertakings costing over $100,000.

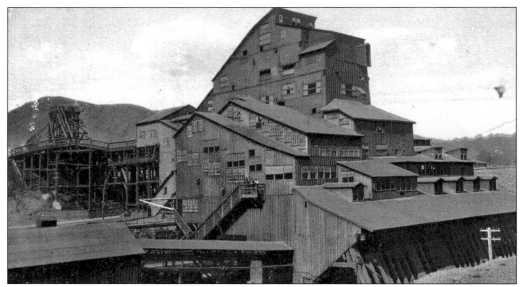

Pictured is the Luke Fiddler Colliery in Shamokin, Pennsylvania. Notice the different levels of the breaker and the wooden stairs leading out of the screen room. In 1870, the colliery employed 236 men inside and 108 men and boys outside, and shipped over 100,550 tons of coal to market.

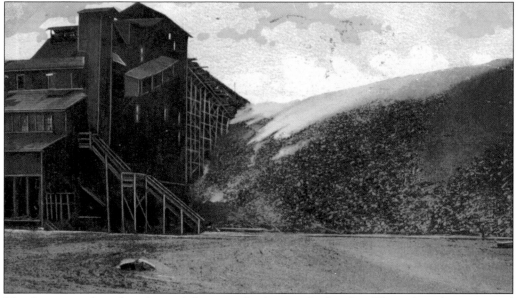

This burning culm pile is located dangerously close to the breaker. The culm piles contained quantities of coal that got by the breaker. These piles of culm frequently caught fire and would sometimes burn for years. At night, the burning coal gave off a blue, orange, and red glow that could be seen all over the surrounding area. The toxic smell of sulfur fumes permeated the area for miles.

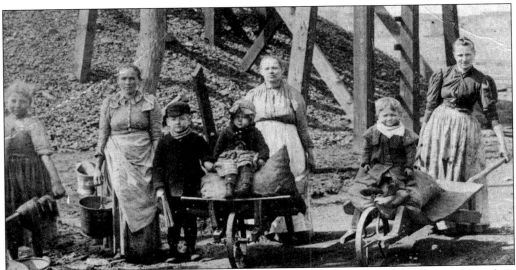

Women and children haul bagged coal from the dumps or from loaded cars that were on their way to market. Taking coal in this method was highly frowned upon by the company, but the women and young children needed the coal for home heating and cooking.

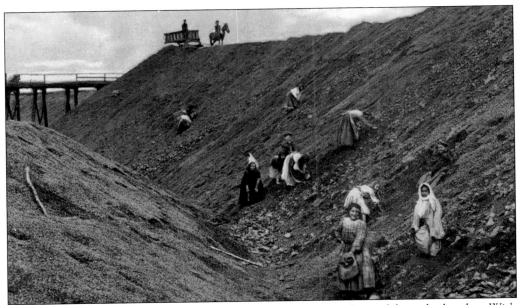

Women and young girls pick the coal out of the culm that was dumped from the breaker. With winter coming on, many homes were heated by coal from the refuse banks.

Glossary

black damp A mine gas consisting of carbon dioxide mixed with nitrogen, given off by the coal seam during an explosion. Heavier than air, it hangs low on the floor of the mine.
breaker A building in which the anthracite coal is prepared for market. The coal is crushed and separated into different sizes.
breast The miner's workplace, called a chamber by workers in the anthracite coal fields.
butty The laborer, or fellow miner (an old term used in the collieries of Great Britain).
cage The apparatus in the shaft used for hoisting men and coal.
car A small, four-wheeled vehicle made of wood or metal in which coal is loaded.
colliery The complete mining plant.
collier A miner.
culm All coal refuse.
doorboy A boy who took care of opening and closing the doors in the gangways.
drift A water-level entrance into a mine.
fire damp Light carbureted hydrogen, known as marsh gas or methane, given off by coal seams. Highly explosive and lighter than air, it hangs high in the breast or gangway.
gangway A passageway driven in the coal, forming the base from which other workings of the mine are begun.
growler The miners' lunch container or canteen, sometimes used for carrying beer.
head frame A device built over top the opening of a mine, used for hosting the loaded cars to the surface.
nipper An errand boy in the mines.
pillar A column of coal left in the mine to support the roof.
seam The correct technical term for a deposit of coal in the ground.
shaft A vertical entrance into a mine.
slate Dark shale lying next to a coal bed.
slope An entrance to a mine driven down through an inclined coal seam.
sprag A pointed stick of wood, about a foot long, used for breaking a car.
spragger An employee who takes care of braking the coal cars, using sprags.
tamping The act of packing a drilled hole around a cartridge with fine dirt from the floor.
trapper boy A doorboy in the mine.
trip A train of mine cars.